IMAGES
of America

SAN ANTONIO'S
CHURCHES

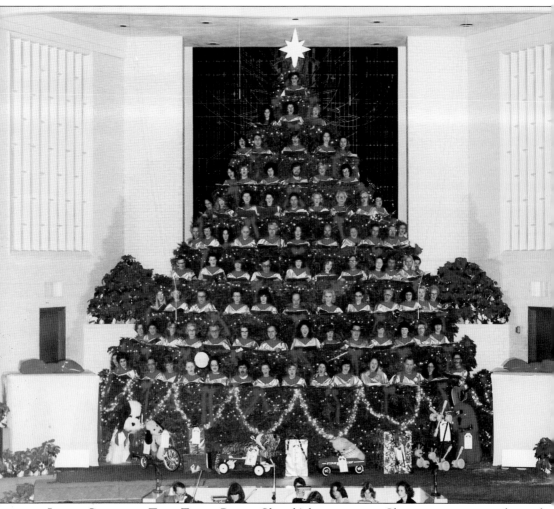

LIVING CHRISTMAS TREE. Trinity Baptist Church's living, singing Christmas tree was made up of choir members performing Christmas carols. Presented by Music Minister Tommy Lyons between 1979 and 1999, it attracted visitors from all over South Texas. (Courtesy of Trinity Baptist Church, San Antonio, Texas.)

IMAGES
of America

SAN ANTONIO'S
CHURCHES

Milo Kearney and Francis Galan

ARCADIA
PUBLISHING

Published by Arcadia Publishing
Charleston, South Carolina

Printed in the United States of America

Library of Congress Control Number: 2011940656

For all general information, please contact Arcadia Publishing:
Telephone 843-853-2070
Fax 843-853-0044
E-mail sales@arcadiapublishing.com
For customer service and orders:
Toll-Free 1-888-313-2665

Visit us on the Internet at www.arcadiapublishing.com

This book is dedicated by Milo Kearney to his wife, Vivian; kids, Kathleen and Danny Anzak and Sean and Lisa Kearney; grandkids, Benjamin, Elijah, and Jeremy Anzak and Ian and Collin Kearney; and aunt Jean; and by Francis Galan to his wife, Emma, and kids, Nicolas and Madison.

CONTENTS

ACKNOWLEDGMENTS

Many thanks for their help to Episcopal bishop David Reed, Catherine and Bill Reed, Lauren Hummer and Caroline Morris at Arcadia Publishing, Tom Shelton and Patrick Lamelle of the Institute of Texan Cultures, Lee Wilder and John Lujan of the National Park Service, Martha Utterbach of the Daughters of the Republic of Texas Library, Brother Edward Loch, C.D. and Freda Barrington, Art and Jan Hall, Marjorie and Joe Brake, Craig Johnson, Jeff Tacker, Betty Curry, Fr. Mathew Martin, Fr. Robert Wright, Lee Thelen, Sister Maria Eva Flores, Liz Bolanos, Lewis Fisher, Chaplain James Berbiglia, Dr. Harry Stephens, the Reverend William Allport, Geraldine Smedler, the Reverend Robert Jemerson, Pastor Cleo Edmunds, Gloria Vásquez, Gary McQuaig, Augustine Tan, Venerable Thich Phuoc Quang, Maria Pfeiffer, Debby Swisher, Christina Ketterling, the Reverend Charles Boerger, Pastor Rachel and Wendell Epp Miller, Walter Iglesias, Fr. Quang D. Van, Fr. Ronald Gonzales, Rabbi Roy Garcia, Bishop Samuel Igelhart, Kit Smart, the Reverend Mario Marzocchi, Jason Navaira, William Sims, Cristina Slaughter, Melanie Lizcano, Fran Everett, Nancy Johnson, Margaret Henderson, Margaret Erickson, Robert Vranes, the Reverend Leo Poore, Rodney Paul Dunn, the Reverend Charles Morris, the Reverend Charles Wedge, Donald Simpson, Doug Clark, Leigh Saunders, Jim Martin, Irene Lieke, Laura Shaver, Dr. Pulin Patel, Brother Suleiman Hamideh, Mikel Allen, Christie Ethington, Jen Osborne, Daniel Guajardo, Robert Harris, Ken Southwood, Peter Clark, the Reverend James Capps, Laurie McMillen, Elaine Dunlap, Ed Nelson, Greg Styles, Vivian Kearney, Sean Kearney, and Kathleen and Danny Anzak.

Our apologies to the many fine churches omitted due to lack of space.

INTRODUCTION

The original buildings of a new town play a major role in establishing its future spirit. The San Antonio de Valero Mission (the Alamo, as it has come to be known) began a religious commitment that has stamped San Antonio's ethos ever since. What was originally a settlement designed, in part, to Christianize the local Indians has evolved into a city that, in 2010, constructed a Haven for Hope project to care for the homeless. The care given by friars to mission Indians for their health needs amidst debilitating diseases established a pattern that was continued by the later founding of church-based hospitals in the city. The schooling of Indians in Spanish culture formed the basis for a notable continuing educational effort by local churches, leading to several church-based universities in San Antonio. The attention given to beauty in the decoration of mission churches was continued in the beautification of later city churches. The support originally lent to religious outreach by the military has also been continued. Modern equivalents of the original Presidio of Béxar are provided by the many military bases in and around the city. Finally, differences of opinion involving the clergy, civilians, and military have found an echo in San Antonio's later religious controversies. Yet the ideal of spiritual, cultural, educational, and medical outreach has transcended all of the imperfections and has left an indelible mark on the town.

San Antonio's churches have experienced many distinct phases of development. The Spanish period, from 1718 to 1821, saw the rise of a brand new settlement out of the founding of five missions (San Antonio de Valero, Concepción, San José, San Juan Capistrano, and San Francisco de la Espada), the presidio, and town of San Antonio de Béxar. This was a time of struggle for mere survival, as the Catholic clergy taught mission Indians the essentials of Christianity while enduring raids from the independent Apache and Comanche Indians. After the secularization of the missions, they became parish churches within San Antonio.

The Mexican Period, from 1821 to 1836, witnessed the arrival of Anglo-American settlers. Their presence created a dilemma for the Catholic Church. Fears of Protestantism played a role in the conflict that culminated in the battles of the Alamo and San Jacinto in 1836. Seven months before his death at the Alamo, Col. William Barrett Travis wrote a letter to the Methodist *New York Christian Advocate* appealing for five Methodist missionaries to be sent to Texas. The religious (as well as the political and economic) dilemma reached its height in the shifting military occupations of the town during the Texas revolt of 1835 and 1836.

The Republic of Texas, from 1836 to 1845, witnessed continuing attempts on the part of Mexico to reoccupy San Antonio. In 1842, two raids from Mexico caused the six Anglo women in town to flee with their children. With the disruption of the Catholic Church in the Texas War for Independence and the small number of Protestants settled in the city, religion was at a low point in San Antonio for 10 years after the fall of the Alamo.

In the early state period, from 1845 to 1860, Protestants established more congregations. The city continued to function as a strategic frontier military post, perpetuating the local connection between the military and the churches.

Many San Antonians were opposed to joining the Confederacy, but, once Texas had done so, they—and their churches—were under pressure to support it in the Civil War.

The Reconstruction Era, from 1865 to 1873, put pressure on the churches to take a stand regarding the proper Christian view of slavery and black churchgoers. Mount Zion First Baptist Church, dedicated to ministering to African Americans, opened in 1871.

The late 19th and early 20th centuries saw San Antonio transformed by a technological revolution, including the arrival of the railroad, which required attention to the problems of a rapidly growing and diversifying urban population. During this time, German immigrants especially left their impact on the religious scene.

New denominations did not always find it easy to start from scratch. An interesting illustration is provided by the Christian Church (Disciples of Christ). David Pennington, the first evangelist of this denomination to come to San Antonio in 1883, preached a series of sermons at various locations. After he preached in Travis Park, the city council passed an ordinance forbidding preaching there, so he began to preach in private homes until a frame Central Christian Church building was constructed in 1884. Even then, lack of income to support his family (due in part to his stand in a disagreement over whether to allow a church organ and to establish church organizations) caused Pennington to leave in that same year. By 1885, the church seemed to be defunct. Then, in 1889, a new pastor, John Stevens, held a revival and brought in 100 new members. However, after some of the members criticized his wife for wearing a fancy black-laced dress the next year, Stevens became offended, abruptly resigned, and did not even hold the scheduled service that Sunday evening. This event did not end the travails of the new church. William Craig, pastor from 1893 to 1897, in his very first year faced the defection of some of his congregation who opposed having societies or an organ. This quarrel prompted Episcopal bishop Johnston to call for Christian unity in a newspaper article entitled "Too Many Preachers." Pastor Craig responded that Christians cannot be expected to agree on man-made doctrines.

The Progressive Age, at the turn of the 20th century, stimulated church outreach to the needy with its emphasis on social reform. The period of the two world wars, from 1914 to 1945, reinforced the long-standing symbiosis between the religious and military institutions in the city because of the proliferation of military bases around the area. Many military personnel, after discharge, settled in San Antonio and joined its churches, establishing a pattern that has continued ever since.

The Roaring Twenties introduced a need to deal with spiritual problems of prosperity, just as the Great Depression brought a call for help to alleviate poverty. In the 1920s, after radio's home entertainment lowered Sunday evening church attendance, churches began to broadcast sermons on the radio. Many people turned to religion due to the impact of World War II. In 1941, the first sermon of Floyd Bash, a pastor of Central Christian Church, was entitled "Building with God in a Hitlerized World."

The post–World War II era saw an even greater challenge from postwar prosperity because of its pull to secular and worldly values. As the radio had in the 1920s, television allowed churches to reach home audiences in the 1960s.

The start of the 21st century has been accompanied by a spiritual challenge posed by a new economic downturn. Downtown churches have reached out to the needs of homeless people and struggled with the threat of burglary. Lighting of church grounds has been increased, security bars and burglar alarm systems have been installed, and armored cars have been used to convey checks and cash to the banks.

With a shift in social mores, opposing views have created divisions among and in the churches on such issues as interpretations of Bible prophecy, the nature of church authority, the role of women, abortion, the view of homosexuality, same-sex marriage, and pastoral conduct. Restrictions against ordaining women ministers have been challenged. Travis Park Methodist Church, for example, hired its first female pastor in 1988, and Grace Lutheran Church followed suit in 1990. José Gómez, a priest of Opus Dei and Catholic archbishop of San Antonio from 2005 to 2010, returned the diocese to a more conservative commitment, while, on the Protestant side, John Hagee of Cornerstone Church likewise expressed the conservative point of view.

New developments have polarized some congregations from within. An increase of Spanish speakers has brought experiments with bilingual services—a difficult feat since it attempts to balance the needs for resources of two congregations in one. Similarly, a debate over whether to maintain traditional music (as desired by most older worshippers) or to turn to contemporary music (as preferred by young adults) has undermined the tradition of having several generations of a family worship together, accelerating the dissolution of the traditional extended family structure.

Each of the above historical periods has left a distinctive stamp on the face of the city, from Franciscan mission style through Neoclassical and Gothic Revival to contemporary architecture. As with any human endeavor, controversy has accompanied San Antonio's church development from first to last. The founding friar of the Alamo, Fray Antonio de San Buenaventura y Olivares, created friction with his criticisms of the governor, presidio soldiers, and mission Indians. The fact that Indian desertions were common in the early missions suggests that life was less than idyllic there. In 2004, Castle Hills Baptist Church lost a suit against an unsympathetic town government of the suburban enclave city of Castle Hills to build a badly needed parking lot on land owned by the church. Yet, despite colonial and modern problems, the churches have made a major positive impact with their sponsorship of schools, hospitals, charities, cultural events, and with their reminder of Jesus's call for people to love one's neighbor as oneself and to do unto others as people would have others do unto them.

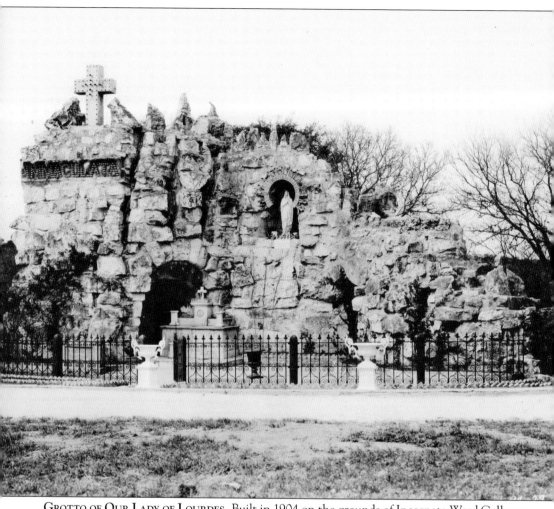

GROTTO OF OUR LADY OF LOURDES. Built in 1904 on the grounds of Incarnate Word College on Broadway, this is a replica of Our Lady of Lourdes Grotto Shrine in southern France. The Oblate College also has a replica of the shrine on its grounds. (Courtesy of University of Texas at San Antonio Libraries Special Collections, 083-0540, General Photograph Collection.)

One

THE SPANISH AND MEXICAN PERIODS

The Alamo is remembered for the battle that took place there in March 1836. However, its Christian missionary outreach was equally important. What came to be called the Alamo was founded in 1718 as Misión San Antonio de Valero by Padre Antonio Olivares, alerting the French court that Texas was Spanish territory. San Antonio's religious purpose was amplified by the addition of four more missions in the area: San José in 1720, Nuestra Señora de la Purísima Concepción, San Juan Capistrano, and San Francisco de la Espada in 1731.

In the same year of 1731, fourteen families arrived from the Canary Islands, induced to settle by being granted noble status with the title of hidalgo and land grants. In 1755, they completed the building of the Church of San Fernando (named for Castilian *reconquista* hero King Fernando III), replacing the chapel they had erected in 1731. Although the Alamo Mission was dissolved in 1793 and the other four missions in 1794, the churches or chapels of the latter four still serve today as parish churches.

The Anglo settlers in the early days of the Mexican Republic after 1823 were legally committed to Catholicism. Nonetheless, Joseph Bays, Baptist minister friend of the late *empresario* Moses Austin, was arrested in 1823 for preaching Protestantism and sent to stand trial in San Antonio, but he escaped on the way. In 1830, Sumner Bacon, a Presbyterian missionary, was caught covertly proselytizing in San Antonio and likewise fled to escape arrest. In 1834, Mexican president Valentín Gómez Farías granted Texas settlers religious freedom, ending the status of the Catholic Church as the established religion of Texas. The resulting fear of Protestantism, especially with Santa Anna's support of the Catholic Church, played a role in the conflict that culminated in the battles of the Alamo and of San Jacinto, bringing Texas independence in 1836.

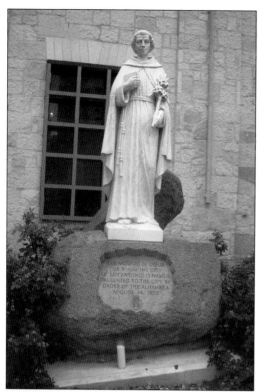

THE CITY'S PATRON SAINT. This statue of San Antonio de Padua stands outside of San Fernando Cathedral. Missionaries passing by on his feast day in 1691 named the site for this 13th-century Portuguese Franciscan. Known for his sermons, the saint had condemned greed. At a rich man's funeral, he had warned, "This man's heart is with his treasure," and when the man's money chest was opened, his heart was found inside. (Photograph by and courtesy of Kathleen Anzak.)

THE ORIGINAL SITE OF THE SAN ANTONIO DE VALERO MISSION (THE ALAMO). This first of the local missions was established in 1718 by Franciscan friar Antonio Olivares. The Presidio of San Antonio de Béxar was founded a short distance away. The Ximenes Capilla de los Milagros (Chapel of the Miracles), shown here, was built in the 1850s to 1870s on what was a ranch by then. It allowed the ranchers to worship at home, which warded off marauding Indians. (Photograph by and courtesy of Kathleen Anzak.)

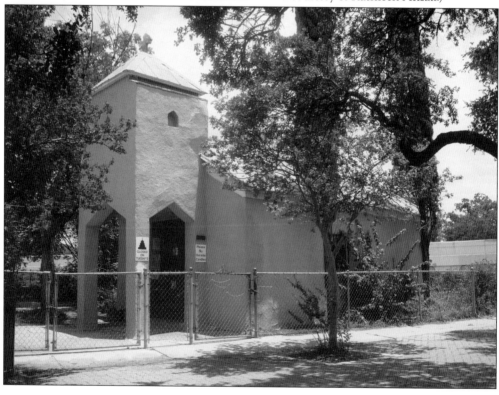

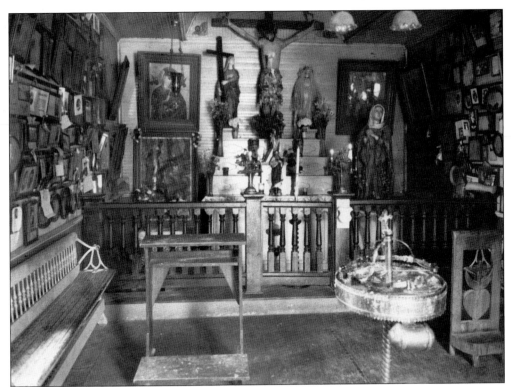

INSIDE THE XIMENES CHAPEL OF THE MIRACLES. The crucifix and other holy items are believed to have come from the Alamo church. This is all that remains of the homestead of Juan Ximenes, a scout and member of Juan Seguín's cavalry who fought against a Mexican army in the Siege of Béxar during the Texas Independence War. The cross on top of the chapel bears the date 1813. (Courtesy of University of Texas at San Antonio Libraries Special Collections, 074-0072, Ellen Quillan Collection.)

WOODEN CRUCIFIX OF EL SEÑOR DE LOS MILAGROS IN THE XIMENES CHAPEL OF THE MIRACLES. When the Alamo was secularized in 1793, Juan Ximenes was purportedly allowed to take this crucifix (believed to be of Spanish origin) and other items from the Alamo chapel to his ranch, carrying the crucifix on his back. Photographs of people for whom healing is being asked are placed beside lighted candles before the altar. (Courtesy of University of Texas at San Antonio Libraries Special Collections, 103-0037, General Photograph Collection.)

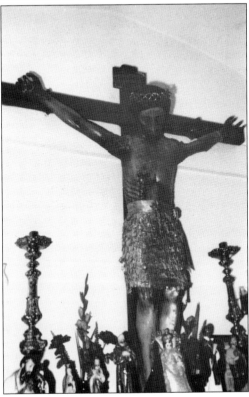

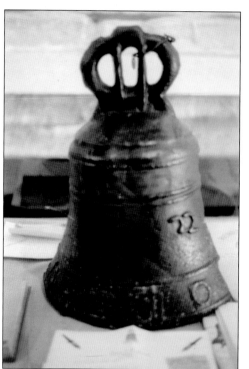

THE 1722 BRONZE BELL FROM MISSION SAN ANTONIO DE VALERO (THE ALAMO). In 1719, Mission San Antonio de Valero was moved to a better-irrigated site near its original location west of the San Antonio River. Then, in 1722, the presidio was moved to its permanent location. (Courtesy of University of Texas at San Antonio Libraries Special Collections, 070-0906, General Photograph Collection.)

THE SAN ANTONIO DE VALERO (ALAMO) MISSION. The mission (shown here in the 1860s) was relocated to this present site in 1724. The townspeople worshipped at the Alamo Church briefly in 1731 until a temporary chapel was built in the Presidio San Antonio de Béxar (whose final name was added to honor the *duque* de Béxar, brother of the Viceroy of Nueva España and a Christian hero who died defending Budapest from the Turks). (Courtesy of the Hearst Corporation and the University of Texas at San Antonio, #L-2355-H.)

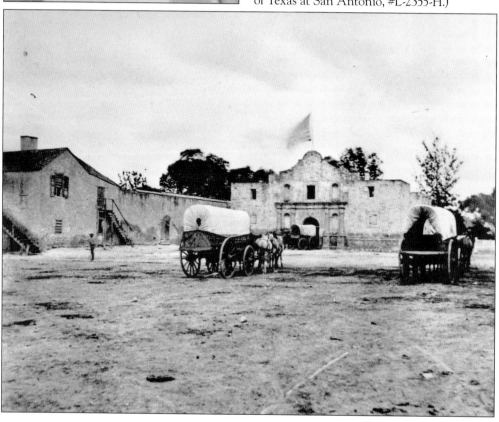

Franciscan Padre Antonio Margil de Jesús. This painting is copied from a photograph of an original watercolor. Padre Margil fled from East Texas to San Antonio in 1719 during a French attack from Louisiana. San Antonio mourned his death on August 6, 1726, with a Día de los Misiones. (Courtesy of University of Texas at San Antonio Libraries Special Collections, 096-0954, University of the Incarnate Word.)

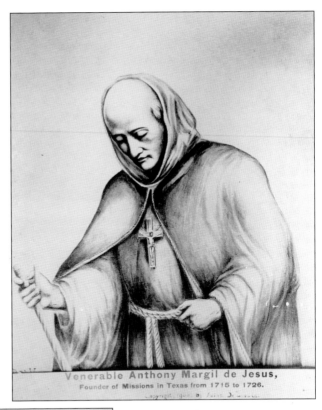

Venerable Anthony Margil de Jesus, Founder of Missions in Texas from 1715 to 1726.

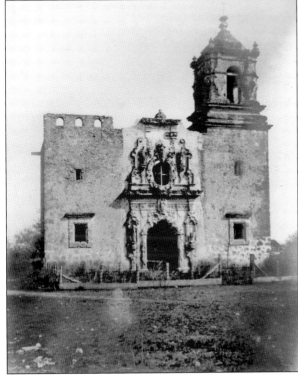

San José y San Miguel de Aguayo Mission. Founded in 1720 by Padre Margil and the governor of Texas, the Marqués de San Miguel de Aguayo, this church was built from 1768 to 1782. The Indians in the Spanish missions lived in family quarters built into the walls, and they farmed and ranched on the mission lands. (Courtesy of Virginia Essington, 101-0087, and University of Texas at San Antonio Libraries Special Collections.)

15

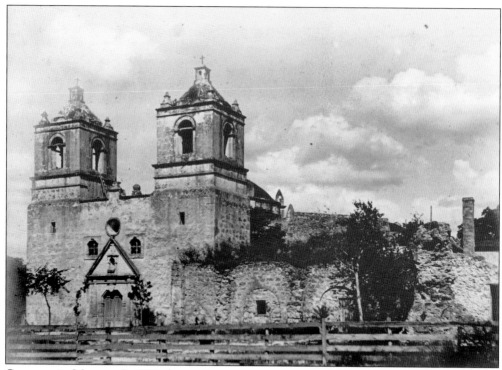

Concepción Mission. In 1731, three other missions were moved from East Texas to San Antonio following military base realignment, giving San Antonio five Spanish missions in all. Nuestra Señora de la Concepción, first founded in East Texas in 1716, was the only one of the three to keep its original name. It stands a quarter-mile east of the San Antonio River. (Courtesy of University of Texas at San Antonio Libraries Special Collections, 101-0100, source unknown.)

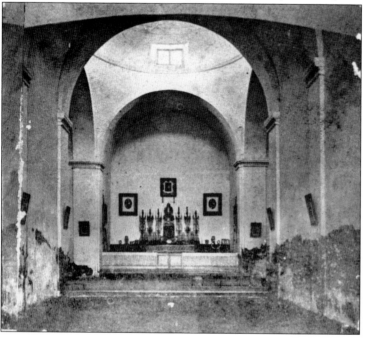

Interior of the Concepción Mission Church. Dedicated in 1755, this is the best preserved of all the mission churches in Texas. The mission was partially secularized in 1794, and its lands were divided among its remaining 38 Indians. Total secularization followed in 1824. (Copy courtesy of University of Texas at San Antonio Libraries Special Collections, 075-1200, San Antonio Conservation Society.)

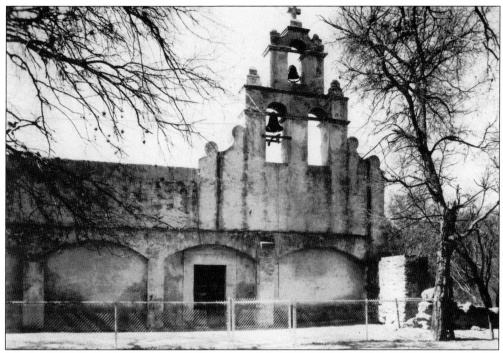

SAN JUAN CAPISTRANO MISSION. A *campanario* (a wall that holds bells) rises over the entrance. Founded originally in East Texas in 1716 as San José de los Nazonis, it was built on its present site in 1731. It was named for the Italian Franciscan theologian San Juan Capistrano, who recruited troops and contributed to the Christian victory over the Turks at Belgrade in 1456. (Courtesy of Ann Russell, 083-1079, and University of Texas at San Antonio Libraries Special Collections.)

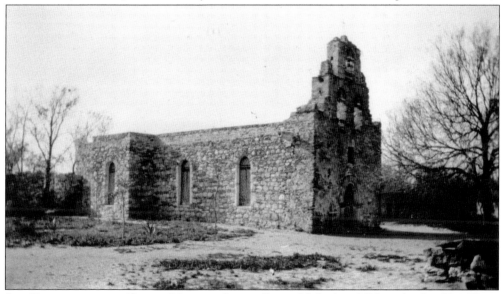

SAN FRANCISCO DE LA ESPADA MISSION. Originally established in 1690 as the first East Texas mission under the name of San Francisco de los Tejas, this mission moved to its present site on the San Antonio River in 1731. (Courtesy of Harold H. Arnold, 100-0485, and University of Texas at San Antonio Libraries Special Collections.)

SAN FERNANDO CHURCH.
San Fernando Church as it appeared in the 18th century is shown in this 1988 drawing by José Cisneros. The oldest cathedral in the present United States, it was built between 1738 and 1755 on the Plaza de las Islas Canarias (Main Square) by settlers from the Canary Islands. After Indian raids demolished part of the church, it was rebuilt in 1796. (Copy courtesy of University of Texas at San Antonio Libraries Special Collections, 088-0377.)

INTERIOR OF SAN FERNANDO CHURCH, C. 1877. The original walls still surround the altar. Here, in 1831, Jim Bowie married Ursula de Veramendi, whose father was mayor and then vice governor of Coahuila and Texas. (Courtesy of Wanda Graham Ford Collection, San Antonio Conservation Society, 088-0315, and University of Texas at San Antonio Libraries Special Collections.)

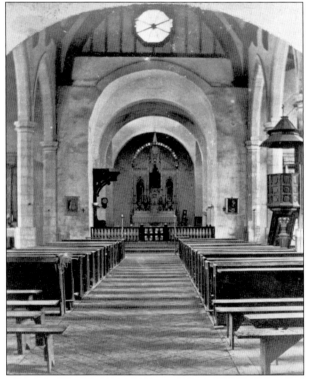

INCORPORATION OF INDIAN IDENTITY. This painting of San Antonio de Padua as a Comanche in St. Anthony of Padua Church reflects an Indian belief that the saint had been one of them. Likewise, in 1749, the town solemnized a treaty with Apaches by digging a hole in the Plaza del Gobierno in front of San Fernando Church and throwing in a hatchet, a lance, six arrows, and a live horse. Indians, soldiers, citizens, and priests danced around the hole three times and then filled it with dirt. (Courtesy of University of Texas at San Antonio Libraries Special Collections, 072-0442, General Photograph Collection.)

AESTHETICS. This photograph shows a baptismal font in Concepción Mission carved by the friars. The encouragement of beautiful art, architecture, and cultural activities has been a feature of many San Antonio churches from the first. (Courtesy of Alice B. Ayres Collection, Ann Russell, 087-0564, and University of Texas at San Antonio Libraries Special Collections.)

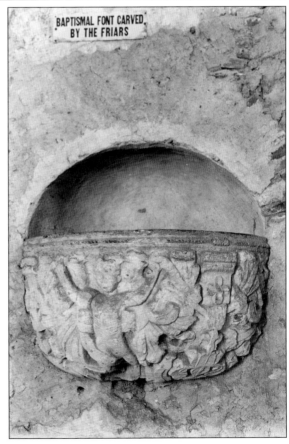

BAPTISMAL FONT CARVED BY THE FRIARS

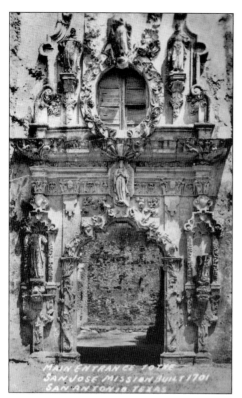

Facade of San José y San Miguel de Aguayo Mission. This is a photo postcard of the facade before restoration. The statues depict Mary as the Virgen de Guadalupe in the middle of the facade with her husband, San José, at the top of the facade and her parents, San Joaquín and Santa Anna, on either side of the door. The founders of the Franciscan and Dominican orders of friars, San Francisco (on the right) and Santo Domingo, flank San José. (Courtesy of Mrs. Jack Fleming, Windmill Museum, 074-1359, and University of Texas at San Antonio Libraries Special Collections.)

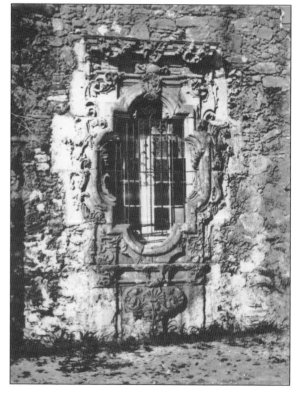

San José Mission's Baroque Rose Window. Legend says it is decorated with roses for Spanish stonemason Pedro Huizar's sweetheart Rosa, who died crossing from Spain, leaving him a lifelong bachelor in mourning. However, the supposed roses are probably pomegranates, Huizar was Mexican, and neither of Huizar's wives were named Rosa. (Copy courtesy of University of Texas at San Antonio Libraries Special Collections, 075-1151, San Antonio Conservation Society.)

INSIDE THE ROSE WINDOW. The name of San José's Rose Window probably derives from the custom of the priest conducting mass in the Sacristy on Pentecost—the feast day of Santa Rosa of Lima—and climbing these inside steps to the window to display the Eucharist to those outside. (Courtesy of University of Texas at San Antonio Libraries Special Collections, 087-0532c, Atlee B. Ayres Collection.)

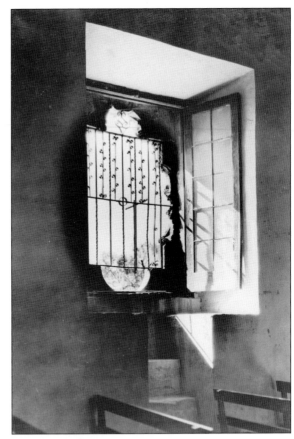

STATUE OF SAN JUAN. At the back of the altar in San Juan Capistrano Chapel stands a statue of San Juan that was brought to East Texas in the 1690s and to this mission around 1740. San Juan is San Antonio's only mission to have three original Mexican-made statues from the colonial period. (Courtesy of San Antonio Missions National Historical Park, National Park Service.)

Statues of Mary and Jesus. These statues, to the right and left of the altar in San Juan Capistrano Mission, date from the 1540s. The statue of Mary (shown here) has no legs under her skirts, and Jesus has only one leg to facilitate carrying the statues in procession on poles, according to the practice of the Mexican villages where they were made. (Courtesy of San Antonio Missions National Historical Park, National Park Service.)

A Posada Held near St. Francis Cabrini Church in 1971. Held on the nine evenings before Christmas, this colonial Mexican tradition reenacts the Holy Family seeking lodging in Bethlehem. In the *gran posada*, people move and sing from Market Square until they are at the cathedral. They are accepted with the song "*Entren Santos Peregrinos*," meaning "Enter Holy Pilgrims." Posadas end with children breaking a piñata, and everyone parties. (Courtesy of University of Texas at San Antonio Libraries Special Collections, 072-1754, General Photograph Collection.)

CAST OF A *PASTORES* (SHEPHERDS) PLAY OUTSIDE OUR LADY OF GUADALUPE CHURCH. A *pastorela* is held every Christmas season at San José Mission and other churches. Dating back to the *Siglo de Oro* (Golden Age), the plays intersperse comic relief with the story of Christ's birth. (Copy courtesy of University of Texas at San Antonio Libraries Special Collections, 070-0369, Joseph W. Elicson.)

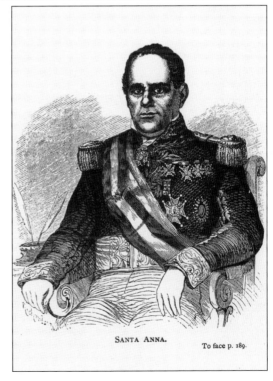

SANTA ANNA.　　To face p. 189.

THE MILITARY CONNECTION. This image shows an engraving of Gen. Antonio López de Santa Ana, president of Mexico during the Texas Revolution. In 1836, before launching his attack on the Alamo, he signaled his policy of no quarter by having the song "*El Degüello*" played and by flying a red flag from the tower of San Fernando Church, where William B. Travis shortly before had posted lookouts to spot Santa Anna's approach. (Courtesy of University of Texas at San Antonio Libraries Special Collections, 075-0553, General Photograph Collection.)

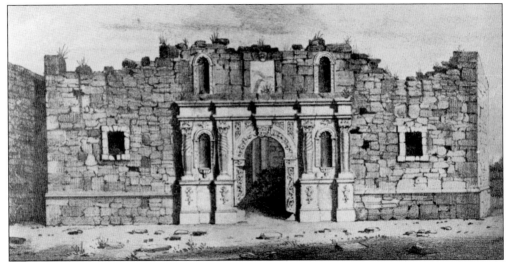

THE ALAMO CHAPEL AFTER THE BATTLE OF THE ALAMO, MARCH 1836. According to local legend, when Santa Anna, after his defeat at the Battle of San Jacinto, ordered General Andrade to destroy the Alamo, the Mexican soldiers were repeatedly driven off by defending ghosts brandishing burning swords. (Courtesy of University of Texas at San Antonio Libraries Special Collections, 099-0659, General Photograph Collection.)

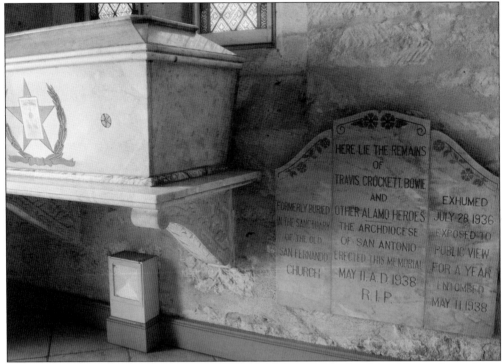

REMAINS OF THE SOLDIERS KILLED AT THE ALAMO. After the Battle of the Alamo, Santa Anna ordered the corpses of the dead soldiers to be cremated. After taking part in the Texan victory at San Jacinto, Col. Juan Seguín buried the soldiers' charred remains under San Fernando Cathedral's altar in April. In 1936, the purported remains were removed to this marble tomb in the cathedral narthex. (Photograph by and Courtesy of Kathleen Anzak.)

Two

THE REPUBLIC OF TEXAS AND THE EARLY STATEHOOD PERIOD

During the decade that Texas was a republic, with its entry bid into the United States denied, some Texans looked to France for protection. Pres. Sam Houston encouraged Texas to receive a loan from the French government, and Jean Dubois, Comte de Saligny, took up residence as French minister in Austin, where his conflict with local resident Richard Bullock unleashed the Texas Pig War. Concurrently, in 1840, a period of French clerical leadership of the local Catholic Church began, lasting until the 20th century. Jean-Marie Odin of France arrived as first vice-prefect apostolic of Texas. Appointed bishop of Claudiopolis in 1842 (a title changed in 1847 to bishop of Galveston), he brought in French Ursuline sisters (who founded the Ursuline Academy for girls in 1851) and French Marianist priests and brothers (who in 1852 opened St. Mary's School for boys, the present Central Catholic High School). Odin revived local Catholicism, helped by an influx of Irishmen, Poles, and especially Germans. St. Mary's Church opened for English-speaking Catholics in 1857 with support from Irish-born merchants and was San Antonio's first professionally designed church, the work of local architect John Fries.

Anglo settlers in this period established San Antonio's typical Hispanic-Anglo, Catholic-Protestant blends. Initially, some Hispanics were driven out. A memorial in San Fernando Cathedral commemorates Eugenio Navarro, shot and killed in 1838 by a newcomer, apparently angered by Navarro's allegiance to Mexico in 1836. In 1842, Mayor Juan Seguín, a hero who had fought the Mexican army at the Siege of Béxar, was chased out of town by Anglo enemies. By 1850, settlers, speaking mainly English and German, had reduced Hispanics to under half of the town's population, a statistic not reversed until 1970.

The few Anglos who had settled in San Antonio before the Texas Independence War, including Samuel Maverick and John W. Smith, mayor in 1837, formed the nucleus of the growing group of Protestants. Presbyterians and Methodists were the first Protestants to offer services in 1844 and were followed by Episcopalians in 1850, Lutherans in 1852, and Baptists in 1855.

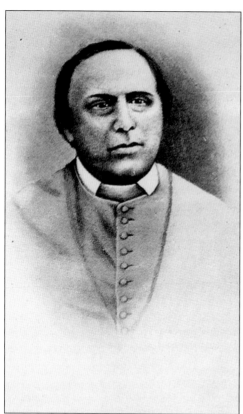

THE INFLUX OF FRENCH CLERGY. Jean-Marie Odin of Lyon, France, was the first Catholic bishop in Texas in 1842 (titled bishop of Galveston from 1847 to 1861). Odin replaced the two native, married priests at San Fernando Church with a Spanish-born clergyman. Recruiting French clergy in 1849, he introduced the Oblates of Mary Immaculate to work with the poor and to launch a seminary to prepare priests. (Courtesy of University of Texas at San Antonio Libraries Special Collections, 072-0821, General Photograph Collection.)

THE URSULINE ACADEMY. The tower of the Ursuline Academy for girls, a school founded on Augusta Street in 1851 by French Ursuline Sisters, featured clocks on three sides but not on the north side—that direction was still lacking settlement. It was jokingly said that Texans would not give the time of day to the Yankee north. The school moved to Vance Jackson Road in 1961, and the original building now houses the Southwest School of Art and Craft. (Copy courtesy of University of Texas at San Antonio Libraries Special Collections, 078-0535, Charles Toudouze.)

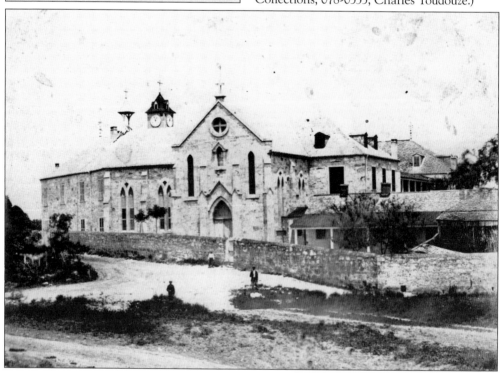

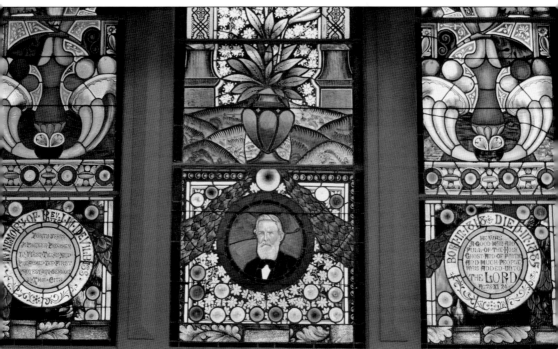

John Wesley DeVilbiss, Travis Park Methodist Church's Window. This Methodist minister came to San Antonio in 1844 with Presbyterian minister John McCullough, both escorted by Capt. John Coffee Hays's Texas Rangers. DeVilbiss conducted the town's first Protestant service at the County Clerk's Office on Commerce Street. (Courtesy of Travis Park Methodist Church, San Antonio, Texas.)

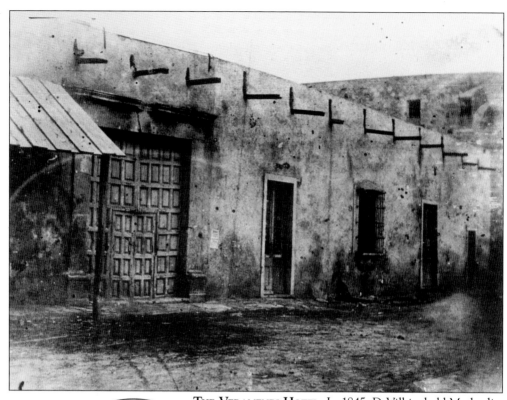

THE VERAMENDI HOTEL. In 1845, DeVilbiss held Methodist services once a month in the Veramendi Hotel on Soledad Street. The former home of Juan Martín de Veramendi, Jim Bowie's father-in-law, this was where Ben Milam had been shot during the Siege of Béxar. In this period, Pastor McCullough preached daily to US troops encamped near San Pedro Springs. (Courtesy of Travis Park Methodist Church, San Antonio, Texas.)

PRESBYTERIAN MINISTER JOHN McCULLOUGH. McCullough, after he settled permanently in San Antonio with his wife in 1846, at first shared preaching in the old courthouse with Methodist minister DeVilbiss. Sermons often had to be shouted in order to be heard over the noise from cockfights on the plaza. DeVilbiss lost his wife and daughter that year but was remarried by McCullough in 1847 to a local girl. (Courtesy of Travis Park Methodist Church, San Antonio, Texas.)

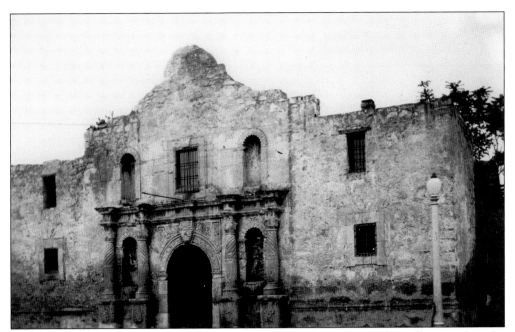

THE CURVED GABLE PARAPET OF THE ALAMO CHAPEL. This facade took shape in 1850, when the Army built a wooden roof to protect quartermaster supplies there. The city sold stone from the Alamo for construction, including stone of the one-room Old Adobe, which was built in 1847 by the Presbyterians on West Commerce near Navarro. Methodists, Lutherans, and Episcopalians also used the Old Adobe as a church. (Courtesy of Ruth Edick, 095-0268, and University of Texas at San Antonio Libraries Special Collections.)

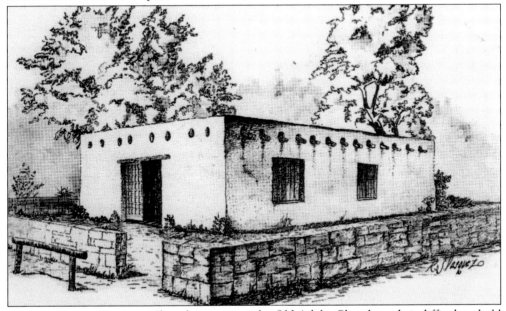

THE OLD ADOBE CHURCH. The saloon next to the Old Adobe Church made it difficult to hold Sunday night services. Presbyterian minister John McCullough received two bullets through his hat from desperado John Glanton, and Methodist minister William Young also narrowly escaped an attempt on his life in 1848. (Courtesy of Travis Park Methodist Church, San Antonio, Texas.)

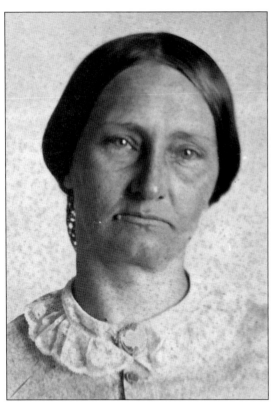

MARY MAVERICK. Samuel Maverick's wife, Mary, encouraged Ambrose Smith to establish an Episcopal church in 1849. After this effort failed, she backed Army chaplain John Fish in forming Trinity Episcopal Congregation, which, from 1850 to 1854, held services in such places as the Old Adobe and the county courthouse. The cornerstone of St. Mark's Episcopal was laid in 1859, but the Civil War delayed its completion until 1875. (Courtesy of Mary M. Fisher.)

OLD ST. MARY'S CHURCH. This church opened on St. Mary's Street in 1857 and was principally for English-speaking Irish. San Fernando Church continued to serve Spanish speakers. (Courtesy of the Southwestern Oblate Historical Archives, San Antonio, Texas.)

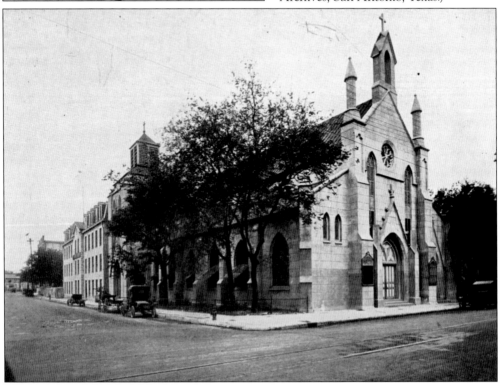

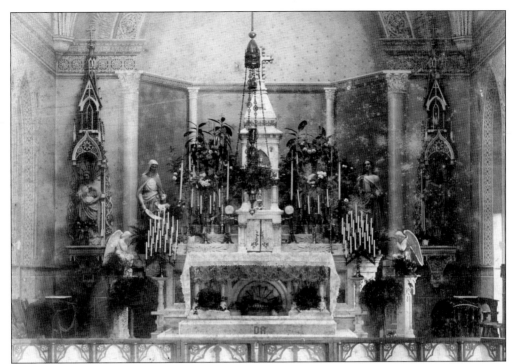

THE INTERIOR OF THE OLD ST. MARY'S CHURCH. From 1874 to 1885, when San Antonio became a Catholic diocese, St. Mary's rectory was used as a residence and chancery office by Catholic bishops Anthony Pellicer and Jean-Claude Neraz. After that, these functions were moved to the new bishop's residence on Dwyer Avenue. (Courtesy of the Southwestern Oblate Historical Archives, San Antonio, Texas.)

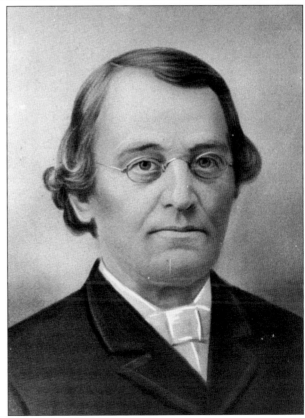

PHILIP ZIZELMANN. In 1852, Lutheran minister Philip Zizelmann arrived in San Antonio. Many of the new German immigrants were nonreligious, and Zizelmann was told that San Antonio did not need any more preachers. Undeterred, he began German-speaking Lutheran services in the Old Adobe Church. He founded St. John's Evangelical Lutheran in 1857 on Nueva Street between Presa and Alamo Streets. (Courtesy of St. John's Lutheran Church, San Antonio, Texas.)

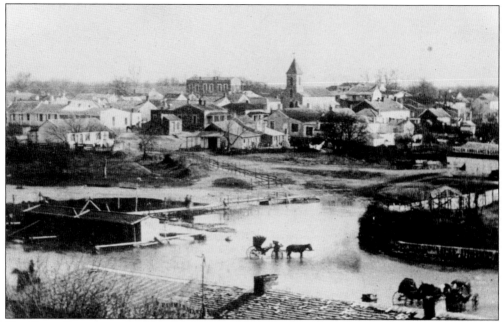

THE FIRST CHURCH OF ST. JOHN'S LUTHERAN SEEN FROM A DISTANCE. This church was built in 1860 on the site where the present church is still located. It was popularly called the rooster church for its weather vane—a reminder of Peter's denial of Jesus on Maundy Thursday. The church can be seen in this photograph, which was taken between 1873 and 1886 from beyond La Villita. A cross replaced the rooster when the church was rebuilt in 1886. (Courtesy of St. John's Lutheran Church, San Antonio, Texas.)

THE SAN ANTONIO RIVER NEAR NAVARRO STREET. This is close to where the first local baptisms by immersion were held. Traveling Baptist ministers had been preaching since 1855. Around the same time, Enoch Jones held services in the courthouse, serving poorer Anglos. In 1857, a passing Baptist missionary, Alfred King, performed the first such baptism for Mrs. E.G. Houston. (Courtesy of First Baptist Church, San Antonio, Texas.)

José Antonio Navarro. Signatory of the Texas Declaration of Independence and a Texas senator, Navarro joined the Methodist church in 1859 at a revival at Paine Methodist Church on Soledad Street. However, in 1871, a Catholic again, he was buried at San Fernando Cemetery. Navarro Street is named for him, and his house still stands. (Copy courtesy of University of Texas at San Antonio Libraries Special Collections, 068-0465, painting by Dee Hernandez, Navarro Elementary School.)

Church Controversy. This image shows the First Presbyterian Church, and Robert Bunting was its pastor from 1856 to 1861. He came to what he called this "wicked city" with "trembling and fear," and, during the financial panic of 1857, called for a spiritual revival. San Antonio's *Daily Herald* created a controversy by supporting Bunting's Presbyterians while criticizing the Catholics. (Courtesy of First Presbyterian Church, San Antonio, Texas.)

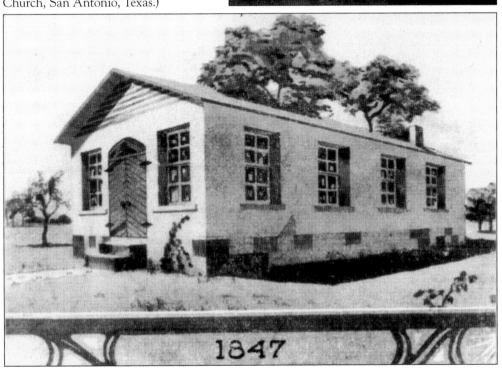

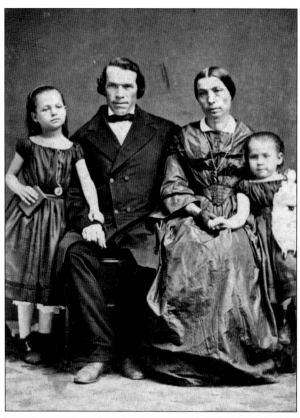

CHURCH-SPONSORED EDUCATION. Pastor Zizelmann, in addition to his duties as pastor, taught in the new English-German day school established by St. John's Lutheran in 1858. The second year, Carl Christian Mayer (shown here with his family) was hired to teach. Mayer later succeeded Zizelmann as St. John's second pastor from 1860 to 1867. The school closed after the introduction of free public education to San Antonio in the 1880s. (Courtesy of St. John's Lutheran Church, San Antonio, Texas.)

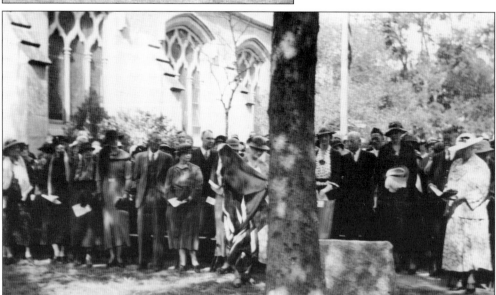

THE MILITARY CONNECTION. Robert E. Lee was an active member of and contributor to St. Mark's Episcopal Church while stationed in San Antonio from 1855 to 1857 and again as commander of the Department of Texas in 1860. A memorial to Robert E. Lee and other founders of St. Mark's was dedicated in the courtyard beside the church in 1935, as is shown here. (Courtesy of St. Mark's Episcopal Church, San Antonio, Texas.)

Three

THE CIVIL WAR AND RECONSTRUCTION

In 1861, San Antonio voters only barely approved joining the Confederacy, and congregations were divided on the issue. Local Germans, whether Catholic or Lutheran, generally opposed secession, as did 46 percent of Bexar County voters. The Unionist newspaper press of James Newcomb, a contributor to St. Mark's Episcopal Church, was destroyed in May 1861 purportedly by the pro-Confederate Knights of the Golden Circle. Newcomb fled to Mexico and returned after the war to become part owner of the *San Antonio Express*. Asa Mitchell, a Knights captain and prominent Methodist, was blamed for many lynchings in this period. Methodist pastor Dr. Jesse Boring and his son joined the Confederate army in 1861. The next Methodist pastor, H.G. Horton, joined the Confederate army in 1862, although he had organized a black Sunday school, using white teachers. St. Mark's Episcopal's rector, Connecticut Yankee Lucius Jones, became a Confederate chaplain in 1861, serving soldiers regardless of affiliation. His successor, William Dalzell, solicited building funds from Confederate sympathizers in England. R.H. Bunting, pastor of First Presbyterian Church, became a Confederate chaplain in 1861, although his parishioners were mainly Unionists. The Baptists supported slavery and the Confederacy.

Outlawry continued to pose a problem for the churches. In 1861, gunslinger Bob Augustine was put on trial for galloping on his horse through the Military Plaza, scattering people, and shooting one man in the leg. He bullied the jury into acquitting him but found a lynch mob waiting for him outside. The Catholic bishop pleaded with the crowds not to hang him, but the exasperated mob strung Augustine up on Military Plaza.

After the war, Baptism and Methodism became the denominations of choice for newly freed blacks. Black Baptists formed the Black Texas Baptist Association in 1866, and 22 newly freed slaves founded Mount Zion Baptist Church in 1871. During the problems experienced in Reconstruction in 1868, Pastor John Martin of First Presbyterian Church predicted Christ's second coming the next year. After that failed to materialize, the Presbytery removed his authority to preach in 1872.

IMPACT OF THE CIVIL WAR. John Thurmond was the founding pastor of the First Baptist Church in 1861–1865. Typical of San Antonio Baptists, he was a Southerner, coming from Tennessee to Victoria, Texas, in 1848. As a missionary preaching in both English and Spanish, he traveled hundreds of miles on horseback. In the Civil War, he headed the local mutual aid society, laboring among soldiers and civilians. (Courtesy of First Baptist Church, San Antonio, Texas.)

THE FIRST BAPTIST CHURCH ON SOLEDAD STREET, ORGANIZED IN 1861. During the Civil War, the First Baptist Church still did not own its church building and suffered from lack of funds and the absence of many men serving in the military. However, the congregation often held services in the courthouse or in homes. (Courtesy of First Baptist Church, San Antonio, Texas.)

The Impact of Reconstruction. Joseph Creath, pastor of the First Baptist Church from 1872 to 1876, came from Virginia as a missionary in 1846. Traveling long distances on horseback, he organized many Baptist churches, supporting his large family without a church salary. He came to San Antonio after its Baptists had gone seven years without a permanent pastor during the trauma of the Confederate loss of the Civil War. (Courtesy of First Baptist Church, San Antonio, Texas.)

Further Ethnic Diversification. This photograph shows the interior of the first St. Michael's Catholic Church, which was dedicated in 1868 on South Street and ministered to people of Polish extraction. Its first priest, Fr. Thomas Moczygemba, was the nephew of Fr. Leopold Moczygemba, who helped bring in Polish settlers from 1854 on. A new brick church would be dedicated in 1967, after the original church was razed to make way for HemisFair Park. (Copy courtesy of University of Texas at San Antonio Libraries Special Collections, 071-504, and Mrs. A.B. Stephens and Mrs. L.T. Botto.)

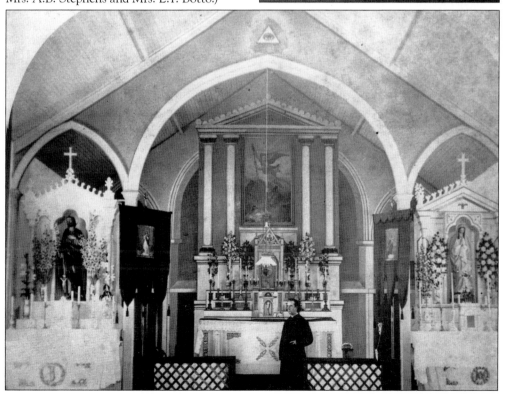

St. Albert's Mutual Aid Society between 1890 and 1900. Based at St. Michael's Catholic Church, this was the first benevolent society formed by Poles in the United States. (Copy courtesy of University of Texas at San Antonio Libraries Special Collections, 071-0516, and Mrs. A.B. Stephens and Mrs. L.T. Botto.)

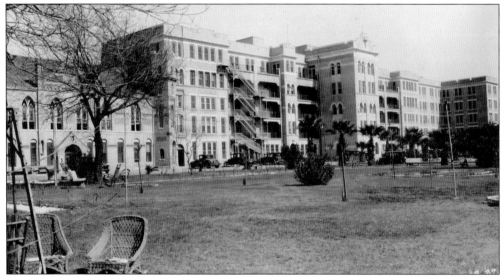

Santa Rosa Infirmary on Houston Street in 1927. Galveston bishop Claude Dubuis recruited French Sisters of Charity of the Incarnate Word to help in a cholera epidemic. In 1869, the sisters founded Santa Rosa Infirmary (the first hospital in San Antonio). This later became the Santa Rosa Medical Center. They also opened St. Joseph's Orphanage and San Fernando School in 1871. (Courtesy of University of Texas at San Antonio Libraries Special Collections, 083-0545, General Photograph Collection.)

ST. JOSEPH'S CATHOLIC CHURCH ON EAST COMMERCE STREET. This church was dedicated in 1871 for German immigrants, since San Fernando Cathedral, where they had been worshipping, emphasized Spanish. In this period, German was heard more frequently in town than Spanish or English, and the *Katholische Rundschau* newspaper was published from 1898 until 1919, when anti-German sentiment forced its discontinuation. (Copy courtesy University of Texas at San Antonio Libraries Special Collections, 088-0311, San Antonio Conservation Society.)

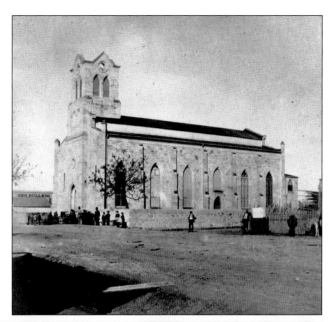

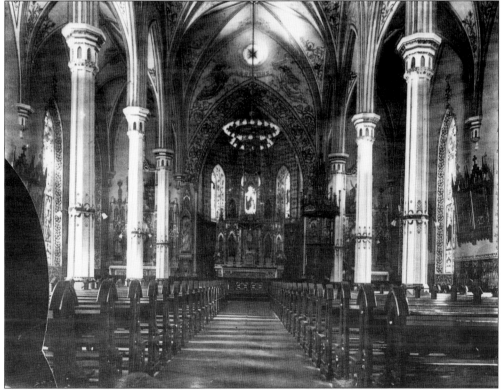

THE NAVE OF ST. JOSEPH'S CATHOLIC CHURCH. When Joske's Department Store was expanded in 1945, St. Joseph refused to sell its land, and so the store eventually expanded around it on three sides. The encircled church was jokingly known in this period as St. Joske's. Dillard's later owned the store. Today, the former store building is part of the RiverCenter Complex. (Courtesy of St. Joseph's Catholic Church, San Antonio, Texas, and 088-0311, San Antonio Conservation Society.)

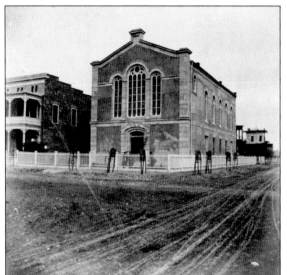

THE ORIGINAL TEMPLE BETH-EL. Ashkenazi Jews were among the settlers from Central Europe in the 1840s through 1870s. The Prussian Louis Zork, head of the first Jewish family to settle in town (by 1847), was instrumental in founding the temple in 1874 on the east side of Travis Park. A Freemason and Odd Fellow, Zork became director of the San Antonio National Bank and treasurer of Bexar County. (Courtesy of University of Texas at San Antonio Libraries Special Collections, 093-0384, General Photograph Collection.)

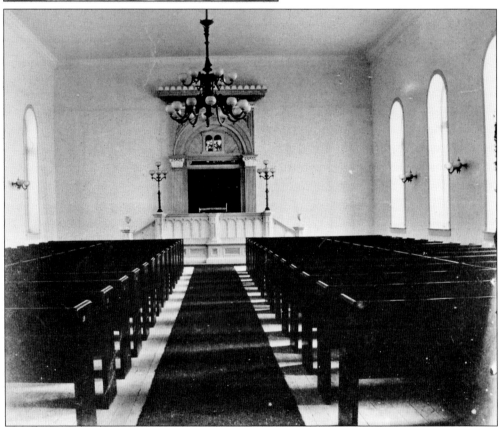

INTERIOR OF TEMPLE BETH-EL ABOUT 1877. The Methodist Church at one point made use of Beth-El. Central Christian's congregation, in the interim between its two church buildings, also met in Temple Beth-El, holding a joint Thanksgiving service with the Jewish congregation in 1896. (Courtesy of University of Texas at San Antonio Libraries Special Collections, 093-0385, General Photograph Collection.)

Four

THE GILDED AGE

In the Gilded Age, San Antonio boomed under the impact of rapid technological changes, especially after the coming of the railroad in 1877. The Baptist churches on Sunset, Prospect Hill, and Flores Streets all began near the city's three train stations at that time. This period left the downtown area dotted with beautiful churches and their stained-glass windows. Anthony Pellicer, the first Catholic bishop of San Antonio (1874–1880), founded many churches and schools and rebuilt San Fernando Cathedral in 1880. Bishop Jean-Claude Neraz (1881–1894) staffed St. Mary's Church in 1884 with priests and brothers of the Oblates of Mary Immaculate who started a series of retreats and revivals. This period also experienced a major push to found Catholic institutions of learning that would eventually grow into universities.

In Protestant church developments, La Trinidad, the city's first Hispanic Methodist church, was founded in 1876. The Salvation Army, an evangelical Christian church emphasizing charity, began local operations in 1889 at the old Joske Department Store on Losoya Street. San Antonio Female College (which had been founded back in 1859 by Paine Church's Methodist pastor Dr. Jesse Boring but then lapsed) was revived in 1894 by Travis Park Methodist Church. In 1918, its name changed to Westmoorland College, and it changed again to the University of San Antonio in 1936. The school merged with Trinity University in 1942. In 1893, West Texas Military Academy was founded by the Episcopal Church south of Fort Sam Houston. Douglas MacArthur, son of the commander of Fort Sam, was a graduate of its first freshman class. It is now called Texas Military Institute and has been located in northwest San Antonio since 1989.

Dwight L. Moody, a leader in the evangelistic movement sweeping the country and who was supported by local Presbyterians and Methodists, prayed at a convention in Houston in 1876 for the ending of San Antonio's moral degradation. This prayer moved the San Antonio *Herald* to deride the participants as "hysterical monomaniacs." Undaunted, Moody carried his "war on sin and sinners" to San Antonio in 1886. As a result of this call, the first San Antonio YMCA was established that same year by First Presbyterian pastor John Neil, who was concerned to keep teenage boys from falling into bad habits.

CONTINUED GROWTH SPURT. Anthony Dominic Pellicer was the first bishop of San Antonio (1874–1880) after the city was named a diocese by Pope Pius IX and San Fernando was named its cathedral. His official residence was at St. Mary's Church. Due to disorderly people disrupting the service, he was obliged to discontinue the tradition of the Christmas Eve midnight mass. He lies buried under the head of the main aisle of San Fernando Cathedral. (Courtesy of the Archives of the Catholic Archdiocese of San Antonio.)

DOWNTOWN TREASURES OF GILDED AGE CHURCHES. St. Mark's Episcopal Church, shown here in 1915, was completed in 1875. Richard Upjohn, an English-born New York architect responsible for that city's Trinity Church at Broadway and Wall Street, laid out the Gothic Revival design for St. Mark's. He gave it broad north and south windows above vertical openings to provide cross ventilation in San Antonio's hot summers. (Courtesy of St. Mark's Episcopal Church, San Antonio, Texas.)

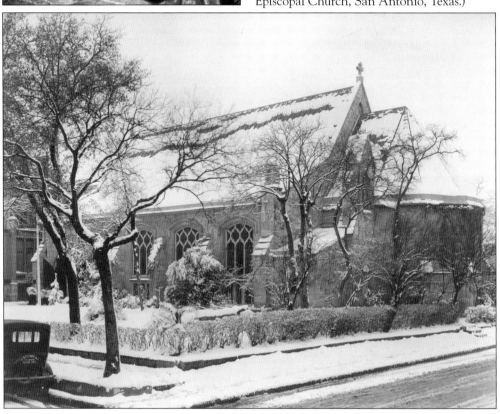

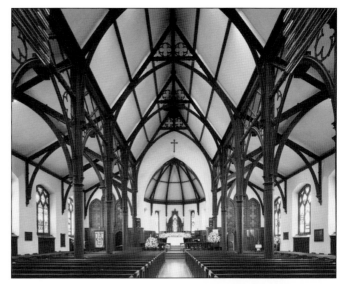

INTERIOR OF ST. MARK'S EPISCOPAL CHURCH. This sanctuary is noted for the wooden ribs supporting its arches. In 1876, Bishop Robert Elliott took St. Mark's as his cathedral church, a status that lapsed in 1888 after Elliott's death the year before. The diocese does not have a cathedral church today. (Photograph by Mike Osborne; courtesy of St. Mark's Episcopal Church, San Antonio, Texas.)

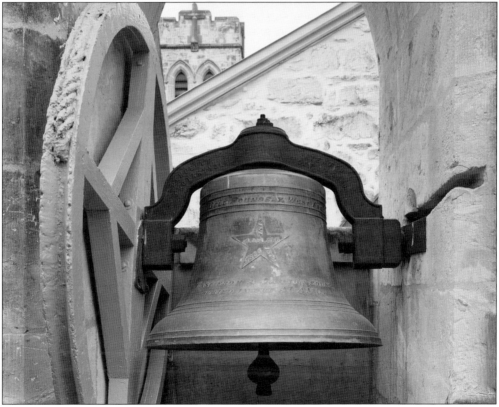

ST. MARK'S BELL. Samuel Maverick donated the copper for St. Mark's Episcopal's bell. Recast from a cannon buried in 1813 and dug up at his home near the Alamo, it was first rung for Easter service in 1875. The term "maverick" for a stray cow or a nonconformist human comes from the negligence of Samuel Maverick's ranch overseer in branding his cows, which, in the days before fencing, wandered outside his ranch. (Photograph by Mike Osborne; courtesy of St. Mark's Episcopal Church, San Antonio, Texas.)

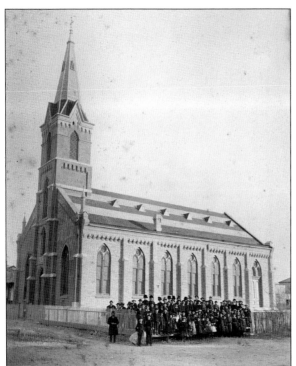

ST. JOHN'S LUTHERAN CHURCH IN 1886. Pastor Wilhelm Krapf and his congregation stand in front of the newly enlarged second building. A large crowd had gathered earlier that year for the laying of the cornerstone, containing a box with the church's history and a list of its members. (Courtesy of St. John's Lutheran Church, San Antonio, Texas.)

FIRST PRESBYTERIAN CHURCH. The Sunday morning services of First Presbyterian Church, completed in 1879 on Houston and North Flores Streets, were often disrupted by drunken revelry at the Buckhorn Saloon across the street. The rowdy mood of the city was a continuing problem for the early San Antonio churches. (Courtesy of San Antonio Conservation Society, 075-1163, and University of Texas at San Antonio Libraries Special Collections.)

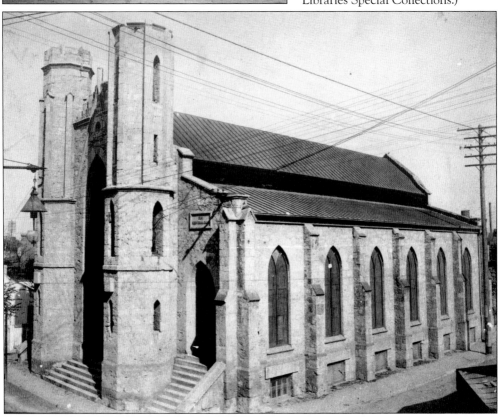

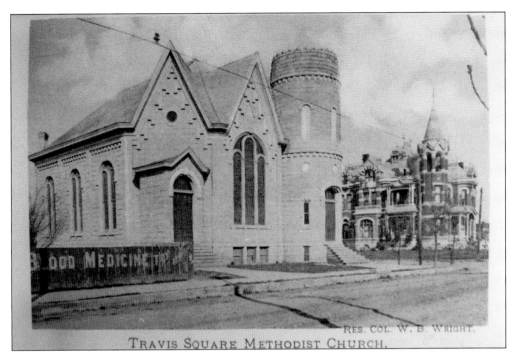

TRAVIS SQUARE METHODIST CHURCH.

RES. COL. W. B. WRIGHT.

TRAVIS PARK METHODIST CHURCH.
The location on Travis Park of this Methodist church, Episcopal and Baptist churches, and a synagogue made this square the center of the most non-Catholic religious life for the city at the time. The Methodist church's first building was completed in 1886. (Courtesy of Travis Park Methodist Church, San Antonio, Texas.)

THE LITTLE CHURCH IN LA VILLITA. This tiny German-language Methodist church in La Villita was built in 1879. Owned since 1945 by the City of San Antonio, it is still used for weddings and non-denominational worship services. (Photograph by Gary McQuaig; courtesy of the Little Church of La Villita, San Antonio, Texas.)

45

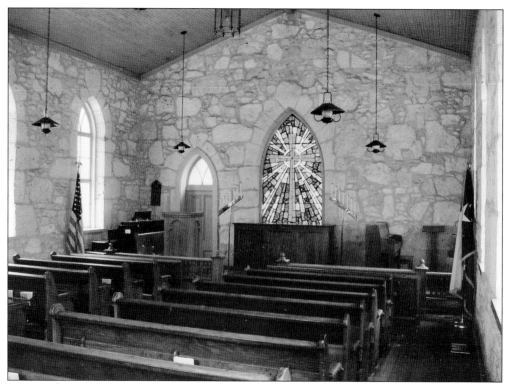

THE INTERIOR OF THE LITTLE CHURCH IN LA VILLITA. On Thursdays, this church holds a healing service that is renowned for miracles. It also provides food for the homeless, funded in part by La Villita's Starving Artist Show, which is held each April. (Photograph by Gary McQuaig; courtesy of the Little Church of La Villita, San Antonio, Texas.)

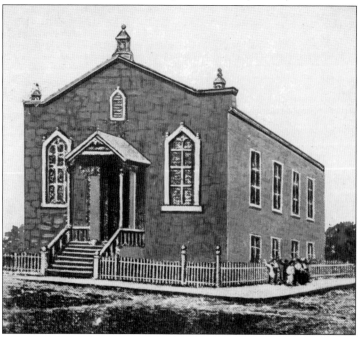

THE FIRST PERMANENT BUILDING OF FIRST BAPTIST CHURCH. This church was completed in 1878 at Travis and Jefferson Streets. A Masonic and Odd Fellows brass-band parade accompanied the placing of the cornerstone in 1872. Evening services began at 5:15 or 5:30 before gaslights were installed in the 1880s, and hymns lacked musical accompaniment until a piano was obtained. (Courtesy of First Baptist Church, San Antonio, Texas.)

SECOND BAPTIST CHURCH. This congregation began in 1879 when Pastor Charles Augustus and 11 ex-slaves, dissatisfied with Mount Zion Church, organized what was named Macedonia Baptist Church until 1904. This magnificent stone building, completed in 1910 on Chestnut and Center Streets, was torn down in the 1960s to make way for an expressway. (Courtesy of Second Baptist Church, San Antonio, Texas.)

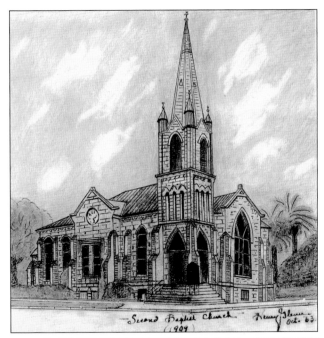

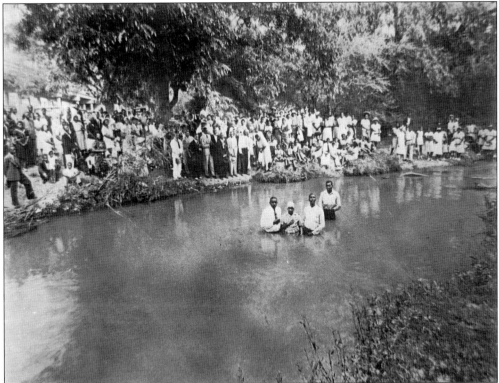

SECOND BAPTIST PASTOR A.W. SMITH, BAPTISM IN THE SAN ANTONIO RIVER IN 1904. Lacking baptisteries, early ministers baptized in the San Antonio River. According to church legend, Smith, after preaching one of his best sermons, unexpectedly rode off in his carriage into the sunset, ending his tenure at the church. (Courtesy of Second Baptist Church, San Antonio, Texas.)

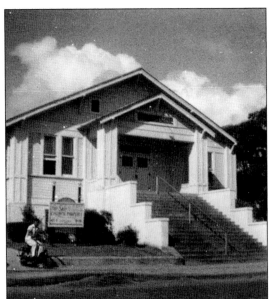

DENVER HEIGHTS CHURCH OF CHRIST. A group of members of Central Christian Church broke away in 1893, objecting to the formation of a missionary society and the purchase of an organ because these were not mentioned in the New Testament. They formed the Pierce Avenue Church—San Antonio's first Church of Christ. In 1909, the congregation moved to the Denver Heights church east of downtown. (Photograph by J. Marshall Butz; courtesy of Kit Smart, daughter of J. Marshall Butz.)

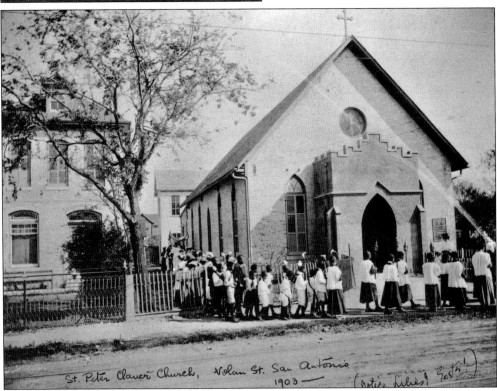

AFRICAN AMERICAN CHURCHES. The Sisters of the Holy Spirit and Mary Immaculate served St. Peter Claver Catholic African American Church (dedicated in 1888). They launched St. Peter Claver Academy, Texas's first free black school, which is now the Healy-Murphy Center. The Methodists, Baptists, and Christians also founded black churches in this period. (Copy courtesy of University of Texas at San Antonio Libraries Special Collections, 074-1177, Sisters of the Holy Spirit and Mary Immaculate.)

ST. PHILIP'S EPISCOPAL NEGRO CHURCH.
Founded in 1895 on Villita Street, St.
Philip's Episcopal Negro Church's services
were initially held in the Little Church
of La Villita. The church sponsored St.
Philip's Normal and Industrial School in
1898 in its rectory, starting with two black
children. The original school building
now houses La Villita's Copper Gallery
and Village Gallery. The school grew
into the present St. Philip's Community
College. (Copy courtesy of University of
Texas at San Antonio Libraries Special
Collections, 101-0063, Ellie Lamb.)

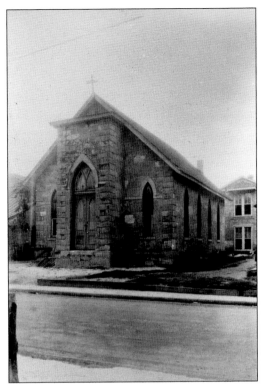

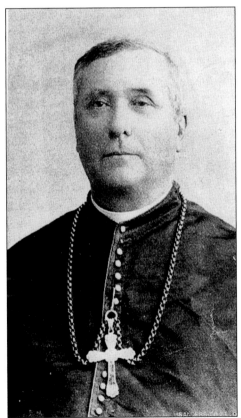

CHURCH-BASED HEALTH CARE. Jean-Claude
Neraz was a French-born Catholic bishop of
San Antonio from 1881 to 1894. Under his
leadership, St. John's Orphanage for Boys
was built and staffed by the Incarnate Word
sisters. During a smallpox epidemic in 1883,
Bishop Neraz visited the sick in tents set up
by city health authorities outside of town in
order to prevent the disease from spreading.
(Courtesy of University of Texas at San
Antonio Libraries Special Collections, 072-
0820, General Photograph Collection.)

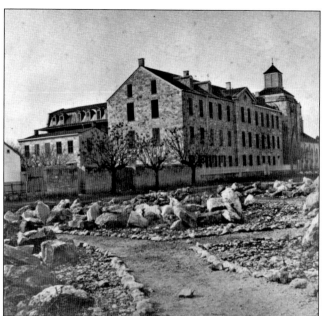

CHURCH-SPONSORED EDUCATION. This image shows St. Mary's College in the 1890s. St. Mary's Institute moved from downtown to the new West End Lake neighborhood and changed its name to St. Louis College in 1893. This later became St. Mary's College and then St. Mary's University, the oldest Catholic university in the Southwest. (Copy courtesy of University of Texas at San Antonio Libraries Special Collections, 088-0308, San Antonio Conservation Society.)

INCARNATE WORD ACADEMY. This school was opened in 1893 by the Sisters of Charity of the Incarnate Word near Fort Sam Houston. In 1897, the Sisters of Charity bought property in Alamo Heights from Col. George Brackenridge, turning his home into their motherhouse. The school grew into the University and Academy of the Incarnate Word. (Courtesy of University of Texas at San Antonio Libraries Special Collections, 083-0541, General Photograph Collection.)

ST. MARY'S HALL EPISCOPAL SCHOOL ABOUT 1882. St. Mary's Hall was founded in 1879 by Bishop Robert Elliott as a school for girls, and it met in Wolfe Hall across from St. Mark's Episcopal Church until 1916. (Copy courtesy of University of Texas at San Antonio Libraries Special Collections, 074-1249, St. Mary's Hall.)

CHURCH AESTHETICS. The 19th-century downtown churches are noted for their array of stained-glass windows. The round window above the three lancet windows in the upper rear wall of St. Mark's Episcopal Church contains the lion symbol of the church's patron saint. (Courtesy of St. Mark's Episcopal Church, San Antonio, Texas.)

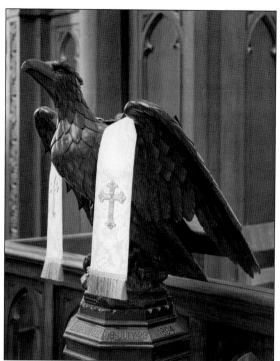

ST. MARK'S EPISCOPAL CHURCH'S LECTERN. This black walnut lectern in the shape of the eagle symbol of St. John was donated in 1894. (Photograph by Mike Osborne, courtesy of St. Mark's Episcopal Church, San Antonio, Texas.)

THE SANCTUARY OF ST. JOHN'S LUTHERAN CHURCH. The sanctuary of the 1886 church contained two interesting items that have been retained in its present structure: the round all-seeing eye window above the altar and the baptismal font. In this period, all its church services were still being held in German. (Courtesy of St. John's Lutheran Church, San Antonio, Texas.)

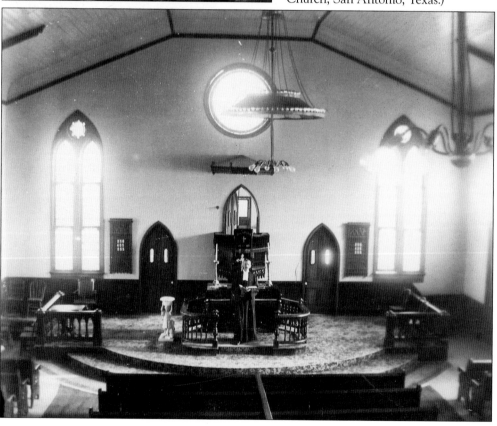

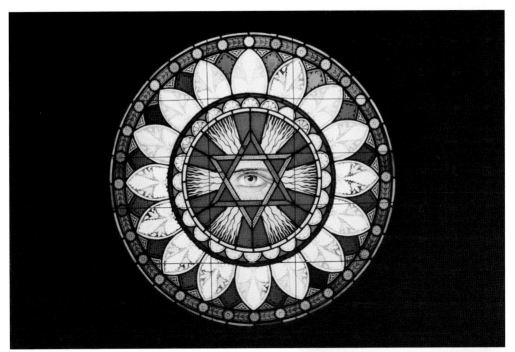

THE OCULUS WINDOW OF ST. JOHN'S LUTHERAN CHURCH. This window symbolizes the all-seeing eye of providence. Once located over the altar of the 1886 sanctuary, it is now incorporated into the library of the present church. The eye of God is shown on the reverse of the Great Seal of the United States and on the dollar bill. Freemasons began to use the symbol about 1790. (Courtesy of St. John's Lutheran Church, San Antonio, Texas.)

THE BAPTISMAL FONT IN ST. JOHN'S LUTHERAN. The font, carved from Carrara marble, comes from the original 1886 church. Located in the baptistery of the 1932 church, it now stands in front of the altar in the sanctuary. (Courtesy of St. John's Lutheran Church, San Antonio, Texas.)

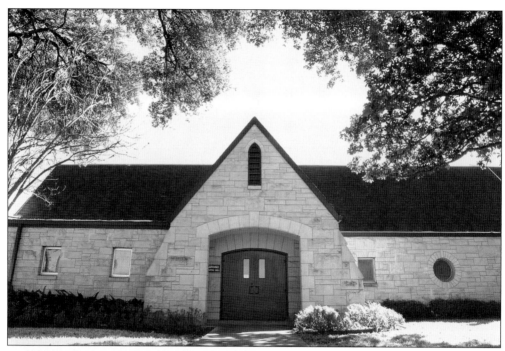

THE MILITARY CONNECTION. St. Paul's Episcopal Church opened in 1884 across from the new Fort Sam Houston. Maj. Gen. Christopher Augur, along with other military officers, led the effort to build the church, which served the post's soldiers. (Courtesy of the Episcopal Diocese of West Texas.)

CHURCH CONTROVERSY. William Dodson, pastor of First Baptist Church from 1877 to 1884, was a former Confederate army chaplain from Mississippi. A quarrel arose over whether a pastor should be hired for more than one year at a time, and some wanted Dodson to resign. Several people were dropped from church membership over this issue or due to accusations of dancing, drinking, or heresy. (Courtesy of First Baptist Church, San Antonio, Texas.)

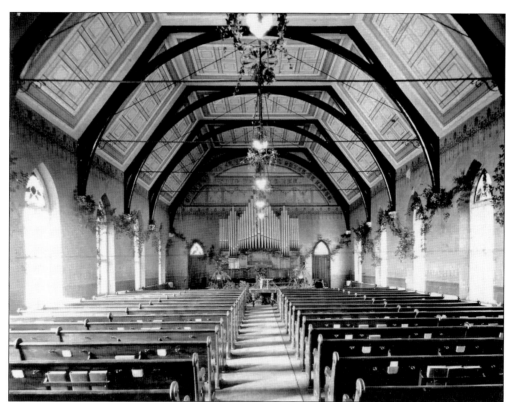

THE SANCTUARY OF MADISON SQUARE PRESBYTERIAN CHURCH. This church was founded in 1882 with the help of George Breckenridge, organizer of San Antonio National Bank. In 1890, thirty-some people transferred here from First Presbyterian after that church dismissed various elders and deacons. In this period, the San Antonio *Herald* supported Presbyterian teaching against the *Freie Presse für Texas*, which believed in multiple routes to heaven. (Courtesy of Madison Square Presbyterian Church, San Antonio, Texas.)

TAXATION DISPUTE. Eustace King (shown here), pastor of First Baptist Church from 1890 to 1896, was an outstanding preacher whose Sunday sermons were published in the *San Antonio Daily Express.* The church filed a legal suit against the city's attempt to tax it. The case was decided in 1898 in favor of the church's exemption from taxes. (Courtesy of First Baptist Church, San Antonio, Texas.)

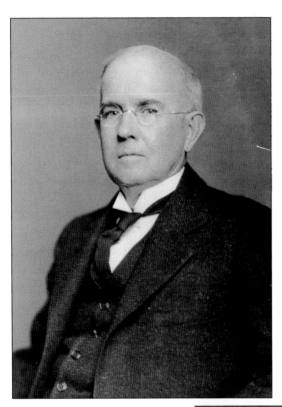

ATTACKS ON ALCOHOL CONSUMPTION. William Young, pastor of Travis Park Methodist from 1880 to 1883, received a death threat for his bold sermons against alcohol consumption, and his effigy was burned in the Buckhorn Saloon. However, after the saloon keeper's child died and Pastor Young comforted the father and buried the child, the attacks on the pastor ceased. (Courtesy of Travis Park Methodist Church, San Antonio, Texas.)

FURTHER ATTACKS ON ALCOHOL CONSUMPTION. John Hackett was the pastor of First Baptist Church from 1884 to 1887. An ex-Confederate chaplain disabled by a wound received at Fredericksburg, Hackett called for the prohibition of alcoholic drinks. In 1885, evangelist Dixon Williams inveighed against saloons and gambling despite disagreement from Catholics, Episcopalians, and Lutherans but received support from Baptists, Methodists, and Presbyterians. (Courtesy of First Baptist Church, San Antonio, Texas.)

Five

THE PROGRESSIVE AGE

In the Progressive Age, San Antonio once again became Texas's largest city, with 100,000 residents in 1911. Social reform was the hallmark of the times. Jean-Antoine Forest, Catholic bishop of San Antonio from 1895 to 1911 and an avid founder of churches, often pitched in to help build them with his own hands. In 1901, he founded the Home for the Colored Poor. The Wesley Community House, offering a free kindergarten, grew out of a sewing school for west-side slum girls. The community house was started in 1910 by the Travis Park Methodist Philathea Sunday school class. The Physicians' and Surgeons' Hospital, the first hospital of the Baptist Health System, opened in 1903. Samuel Porter, pastor of First Baptist Church (1910–1918) and once a missionary in Brazil, wrote *The Shepherd Heart*, expressing concern for the needy.

On the other hand, it became fashionable for some middle-class families to join Episcopal and Presbyterian churches to distinguish themselves from immigrants from southern and eastern Europe. Alamo Heights was developed as a posh new incorporated city.

After 1910, San Antonio was affected by the Mexican Revolution, with an influx of refugees from Mexico. Both Catholics and Presbyterians helped refugees from the Mexican Revolution, and the Mexican Baptist Convention was organized in 1910.

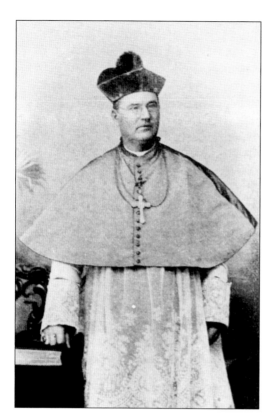

OUTREACH TO MINORITIES. Jean-Antoine Forest, the French-born Catholic bishop of San Antonio from 1895 to 1911, brought in the Claretians in 1902 to take charge of San Fernando Cathedral and minister to its largely Spanish-speaking parishioners. (Courtesy of University of Texas at San Antonio Libraries Special Collections, 072-0816.)

THE MEASURES OF CATHOLIC BISHOP JOHN SHAW. Bishop Shaw (1911–1918) addressed the needs of Mexican American parishioners by insisting that all local candidates for the priesthood be fluent in Spanish before ordination. He also reopened the Spanish missions for worship. (Courtesy of the Archives of the Catholic Archdiocese of San Antonio.)

OUR LADY OF SORROWS MEXICAN AMERICAN CATHOLIC CHURCH. This church was built in 1915 to serve Mexican Americans thanks to a fundraising effort by two Mexican priests from Monterrey, Nuevo León, who had been conducting a mission in Spanish. (Courtesy of the Southwestern Oblate Historical Archives, San Antonio, Texas.)

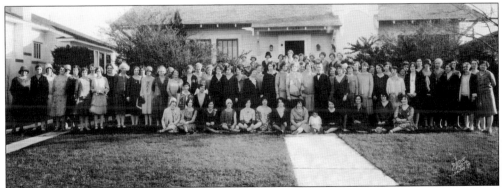

PHILATHEA CLASS OUTREACH TO MEXICAN AMERICANS. This Sunday school class for young women, founded in 1907, followed a New York concept adopted by Travis Park Methodist Church to help immigrant girls from Mexico. In 1910, the program was given to the city and developed into the San Antonio YWCA. (Courtesy of Travis Park Methodist Church, San Antonio, Texas.)

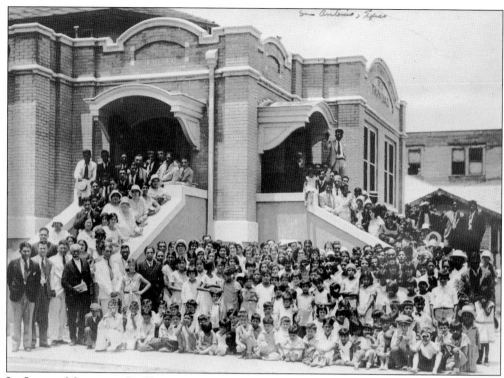

LA IGLESIA METODISTA LA TRINIDAD. Founded back in 1876, this church experienced a swelling attendance in the 1910s with the influx of immigrants fleeing the Mexican Revolution. Central Christian (Disciples of Christ) Church started a church for Spanish speakers and established the Mexican Christian Institute (now the Inman Christian Center) to minister to the refugees. (Copy courtesy of the University of Texas at San Antonio Libraries Special Collections, 092-0334, Kathleen Alcala.)

OUTREACH TO PROSTITUTES. Walter Raleigh Richardson, rector of St. Mark's Episcopal Church, reached out to the women of the red-light district just to the west of San Pedro Creek. In 1896, he bucked controversy to give a Christian burial to a prostitute who had committed suicide, concluding the ceremony by repeating Jesus's words to the woman taken in adultery, "Neither do I condemn you. Go and sin no more." (Photograph by Mike Osborne; courtesy of St. Mark's Episcopal Church, San Antonio, Texas.)

More Outreach to Prostitutes. In 1895, Methodist pastor Dr. W.W. Pinson and his wife prayed with Madame Volvino, owner of a brothel on San Saba Street. This woman, in distress over the death of a daughter, had been moved by a street revivalist to repent. The next day, she went forward at the altar call in Travis Park Methodist Church. She then converted her bordello into the Methodist Mission Home for "fallen women," and it is still in operation. (Courtesy of Travis Park Methodist Church, San Antonio, Texas.)

Church-Sponsored Education. In 1896, the French Sisters of Divine Providence, who had just moved to San Antonio from Castroville, opened Our Lady of the Lake (Lake Elmendorf) Academy on the west side of the city. The academy added a two-year college program for women in 1911, changed to four-year in 1919, and then became a coed campus in 1969. It is now a university. (Courtesy of University of Texas at San Antonio Libraries Special Collections, 083-0539, General Photograph Collection.)

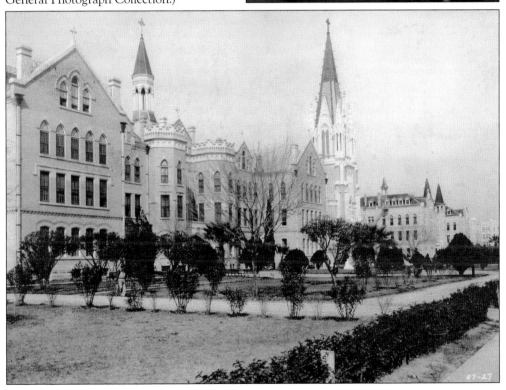

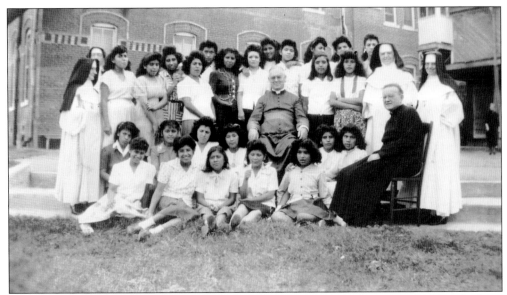

OUTREACH TO ABANDONED GIRLS. The Sisters of Our Lady of Charity opened Our Lady of Victory School (shown here) in 1897 for the rehabilitation of neglected and delinquent girls. (Copy courtesy of University of Texas at San Antonio Libraries Special Collections, 103-0089, Olivia Valero Gordon.)

CHURCH-BASED HEALTH CARE. Grace Lutheran Church set up this makeshift sanatorium in 1913 to help those suffering from tuberculosis (which ran rampant in the city in this period). Since the city did not allow the sanatorium inside its boundaries, the camp was located just west of the city limits on South Zarzamora Street. (Courtesy of Grace Lutheran Church, San Antonio, Texas.)

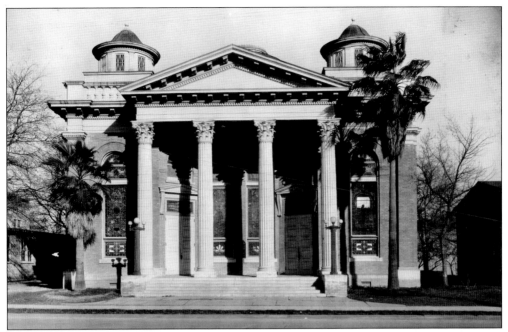

PROHIBITION. Central Christian Church at Main and Camden Streets was dedicated in 1903. When the church windows were opened in hot weather, saloon patrons next door would be heard hurling rude remarks. The church failed in its attempts to shut down the saloon despite a law that prohibited liquor to be sold within 150 feet of a church. (Courtesy of University of Texas at San Antonio Libraries Special Collections, 083-0521, General Photograph Collection.)

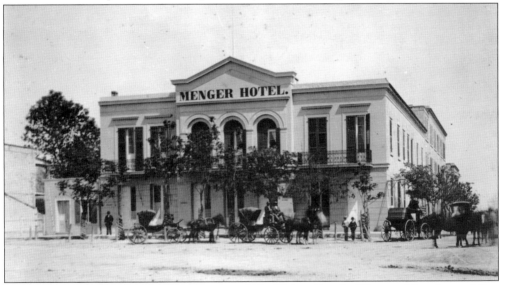

CARRIE NATION'S IMPACT. The appearance in 1908 of 5-foot-11-inch, 175-pound, hatchet-wielding prohibitionist Carrie Nation (with the sympathy of some local churches) in the bar of the Menger Hotel (shown here), which was next to the Alamo, caused the startled bartender to spill his beer. Tradition attributes a hatchet gash through the bar's counter to Carrie, but it seems to have been made instead by a policeman angry over the sale of bootleg whiskey. (Copy courtesy University of Texas at San Antonio Libraries Special Collections, 082-0651, Pioneer Flour Mills.)

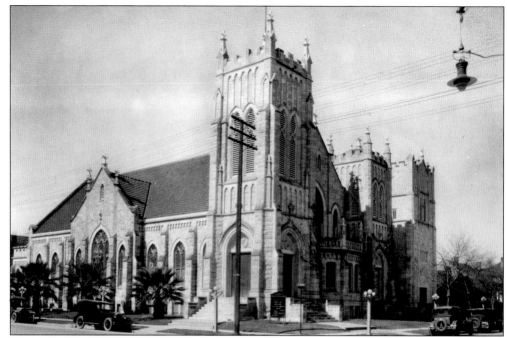

FIRST PRESBYTERIAN CHURCH IN 1927. In 1910, First Presbyterian began to meet in its present church at Fourth and Alamo Streets, although the completed church was not dedicated until 1920. (Courtesy of Ann Russell, 083-0524, and University of Texas at San Antonio Libraries Special Collections.)

CHURCH AESTHETICS. Travis Park Methodist, completed in 1902, developed one of the many fine church choirs in San Antonio. The choir not only performed in the church but also for such outside organizations as Army chapels, Temple Beth-El, and the Scottish Rite Temple. (Courtesy of Travis Park Methodist Church, San Antonio, Texas.)

BEAUTIFUL SANCTUARY OF THE IMMACULATE HEART OF MARY CHURCH. This church was built in 1912 in south downtown to serve a Mexican American parish. Its marble altar was obtained from St. Michael's Polish Catholic Church, destroyed to make way for HemisFair '68. Its Byzantine Romanesque nave decorations have caused the shrine to be declared an exceptional historic landmark. (Photograph by and Courtesy of Kathleen Anzak.)

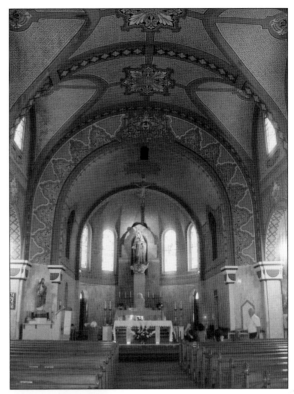

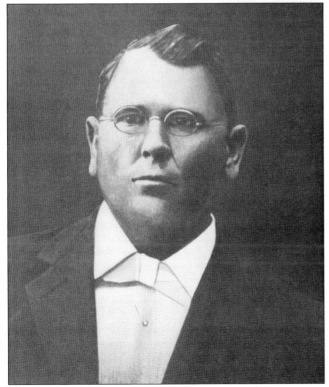

CHURCH CONTROVERSY. Augustus Harris, pastor of First Baptist Church from 1897 to 1904, was a native Texan who had been a cowhand before entering the ministry. Dissension arose at the general Baptist convention in San Antonio in Harris's first year as pastor between Dr. S.A. Hayden, owner-editor of the *Texas Baptist and Herald*, and the convention leaders, resulting in the refusal of the convention to seat Hayden. (Courtesy of First Baptist Church, San Antonio, Texas.)

DEBATE OVER GERMAN OR ENGLISH USAGE. Grace Lutheran's first church building, on McCullough Street and Avenue E, was constructed in 1905. Grace was formed in 1904 by English-speaking members of St. John's Lutheran Church who were unhappy with St. John's Lutheran's policy of using German exclusively. St. John's itself moved toward bilingualism in 1907. (Courtesy of Grace Lutheran Church, San Antonio, Texas.)

THE MILITARY CONNECTION. Pres. William Howard Taft lays the cornerstone at the dedication of Gift Chapel at Fort Sam Houston in 1909. The Gift Chapel was built at Fort Sam Houston to provide a place of worship for the soldiers. Chimes were later donated by Mamie Eisenhower, who lived at the post together with her husband, Gen. Dwight Eisenhower, in 1941. (Courtesy of University of Texas at San Antonio Libraries Special Collections, 076-1032, Hornaday Collection.)

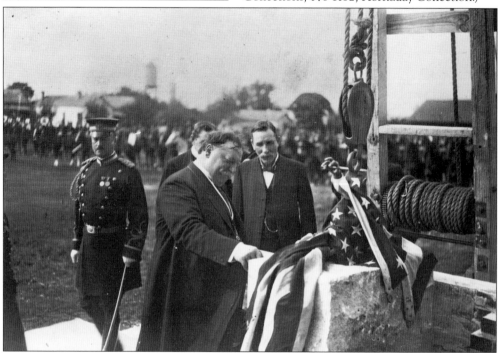

Six

World War I and the Roaring Twenties

The First World War increased the military's impact on the local churches with the opening of Kelly Air Force Base in 1917 and Brooks Air Force Base in 1918. Then, in the Roaring Twenties, American Christianity experienced a new swing of growth and optimism thanks to the victory in the war.

In 1926, the Catholic Diocese of San Antonio was raised to an archdiocese under the direction of Dutch-born Arthur Jerome Drossaerts (bishop of San Antonio since 1918), who served until his death in 1940. In 1927, the Oblates of Mary Immaculate founded the De Mazenod Scholasticate, the present Oblate School of Theology. Drossaerts did not shrink from involvement in social and cultural issues. During the persecution of the Catholic Church in Mexico, which reached its height under Pres. Plutarco Elías Calles (1928–1935) with the Cristero War, Drossaerts spoke out against the lack of American outrage. He secretly worked without a salary, and at his death left insufficient funds for his own funeral and burial in the San Fernando Archdiocesan Cemetery.

Dr. Pierre Hill, pastor of First Presbyterian Church (1922–1940), who preached that it was manly to be Christian, was appointed chaplain of the Texas Rangers. Hill helped rally other Protestant pastors to join in a four-day celebration in 1922, including a grand parade of up to 40,000 marchers starting at Alamo Plaza, to mark the 75th anniversary of Protestantism in the city.

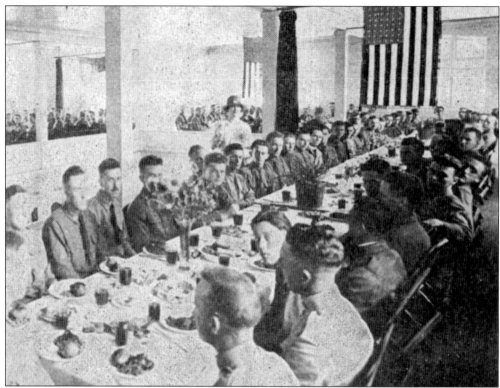

THE IMPACT OF WORLD WAR I. Pictured is one of the regular Sunday dinners served for soldiers during World War I in the parish hall of St. Mark's Episcopal Church. Beds were provided in the hall for soldiers who wished to spend Saturday night in town. First Presbyterian Church also fed soldiers after Sunday worship. (Courtesy of St. Mark's Episcopal Church, San Antonio, Texas.)

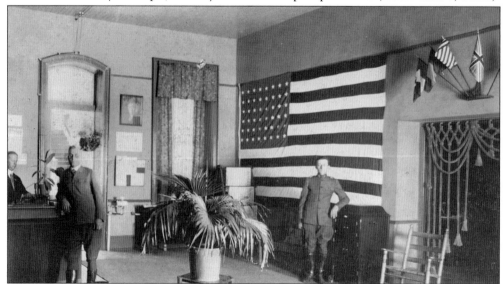

THE LUTHERAN BROTHERHOOD CLUB. Grace Lutheran Church set up this club to allow soldiers sent to Fort Sam Houston, who were preparing for deployment to Europe in World War I, to fraternize with local civilians. (Courtesy of Grace Lutheran Church, San Antonio, Texas.)

NEW UPSWING IN THE 1920S. In 1924, the present St. Mary's Gothic Catholic Church was dedicated in downtown San Antonio. The previous church had been razed in 1923, after the 1921 flood had severely damaged it. (Courtesy of the Southwestern Oblate Historical Archives, San Antonio, Texas.)

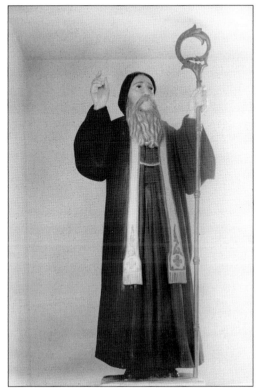

STATUE OF ST. MARON. This saint, who died in 410, had converted a temple of Nabo, god of secret wisdom on a mountain northwest of Aleppo, into a church, and his disciple, Abraham of Cyrrhus, had launched the Maronite Church in Lebanon. The first church of St. George Maronite Catholic was established in 1925 to serve Lebanese Christians. (Courtesy of University of Texas at San Antonio Libraries Special Collections, 068-3060, General Photograph Collection.)

SAN FRANCESCO DI PAOLA CATHOLIC CHURCH. This church was built in 1927 to serve Sicilians. The Sicilians had begun settling in San Antonio in the 1870s but took until 1927 to build their own church because of their anti-clericalism, which was brought with them from corruption-ridden Sicily and reinforced by their disapproval of the Irish domination of the San Antonio clergy at that time. (Copy courtesy of Rev. Henry Herrera, 068-2147, University of Texas at San Antonio Libraries Special Collections.)

ST. ANTHONY OF PADUA CHURCH. The construction of this church was modeled on the architecture of the old Alamo mission church. The original church was built in 1928 due to the concern of Fr. Peter Baque, who felt that it was wrong that San Antonio had no church or shrine dedicated to its own patron saint. (Courtesy of St. Anthony of Padua Church.)

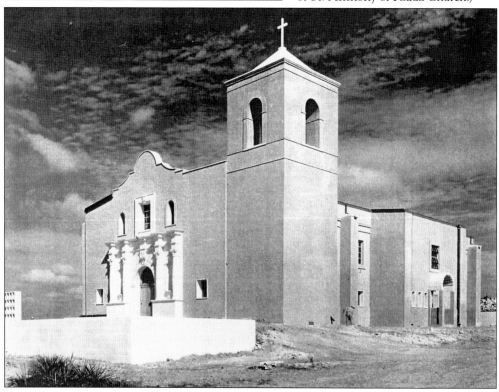

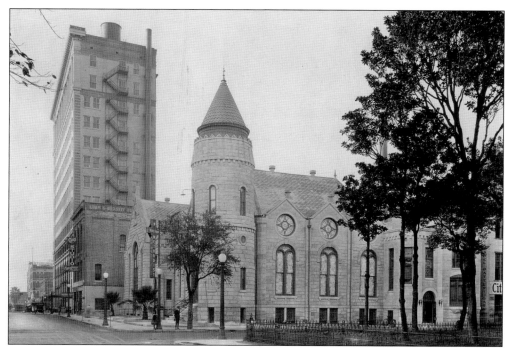

TRAVIS PARK METHODIST CHURCH IN 1922. In 1922, this church hosted San Antonio's Diamond Jubilee of Protestantism with the participation of Presbyterians, Christians (Disciples of Christ), and Baptists. (Courtesy of Travis Park Methodist Church, San Antonio, Texas.)

THE FIRST CHURCH OF CHRIST SCIENTIST. Posters on the church at Alamo and McCullough Streets advertise a Christian Science lecture being held on February 15, 1927. (Courtesy of University of Texas at San Antonio Libraries Special Collections, 083-0526, General Photograph Collection.)

A Baptism in the Guadalupe River at Camp Capers. The 1920s saw the establishment of church camps in the Central Texas Hill Country, including Alto Frio Baptist Encampment (1920) and Westminster Presbyterian Encampment at Kerrville (1920s). More followed in the 1940s, including Episcopal Camp Capers in 1944 and Presbyterian Mo-Ranch in 1949, both on the Guadalupe. There is also a Mennonite camp on the Frio River. (Courtesy of St. Helena's Church, Boerne, Texas.)

Modernization. Dr. Paul Hein, pastor of Grace Lutheran from 1914 to 1935, is shown in the middle at a church picnic in 1934. In 1917, electric ceiling fans were added to the church sanctuary, and the choir began to wear robes. In 1918, the church paid to pave Avenue E from Fourth to Sixth Street because the jitney (share-taxi) traffic from Fort Sam Houston and Camp Travis was constantly covering the pews with dust. (Courtesy of Grace Lutheran Church, San Antonio, Texas.)

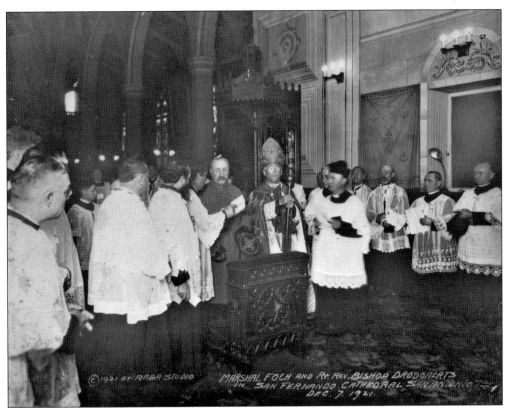

CHANGING FASHIONS. Pictured in the middle here is Bishop Arthur Drossaerts with French marshal Ferdinand Foch in San Fernando Cathedral in 1921. In this period of drastically rising women's hemlines and disappearing sleeves, Drossaerts condemned the display of women's bodies as "formerly the exclusive badge of the scarlet woman" and as a "degrading spectacle of young women being exhibited and appraised like dogs and cattle." (Copy courtesy of University of Texas at San Antonio Libraries Special Collections, 071-0557, Archdiocese of San Antonio.)

CHURCH AESTHETICS. This photograph shows an icon of Christ as the Pantocrator on the ceiling of St. Sophia Greek Orthodox Church on North St. Mary's Street. The new local Greek community was served at first on an emergency basis by priests from Houston or Dallas. In 1924, after a week had passed before a priest could come to bury the daughter of a Greek couple, this church was finally founded. (Copy courtesy of University of Texas at San Antonio Libraries Special Collections, 068-2759, St. Sophia Greek Orthodox Church.)

73

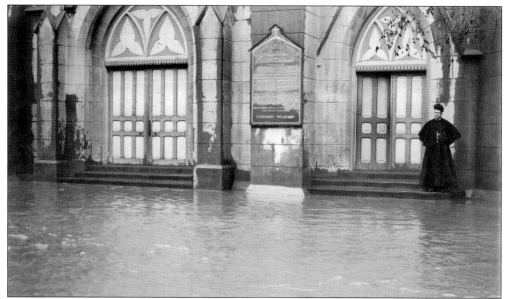

ADVERSITY. Fr. James Quinn stands outside St. Mary's Church during the flood of the San Antonio River in 1921. Flood marks up to 6 feet, 1 inch were also left on the side of First Baptist Church, where the water damaged the organ, pianos, furniture, and songbooks. Losses at Travis Park Methodist included church records and the pastor's desk, which were swept out of the building. Over 50 people were killed. (Courtesy of the Southwestern Oblate Historical Archives, San Antonio, Texas.)

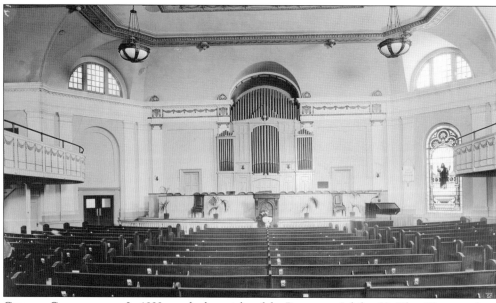

CHURCH CONTROVERSY. In 1922, on the last night of the Protestant Jubilee, Ku Klux Klan members in white robes and hoods marched down the aisle of the Travis Park Methodist sanctuary with a $100 bill contribution to the Jubilee Committee and a letter of support for Protestantism. However, San Antonio and Galveston were possibly the only major Texas cities not under Klan control, and the Methodist bishops and the *Texas Christian Advocate* opposed it. (Courtesy of Travis Park Methodist Church, San Antonio, Texas.)

Seven

THE GREAT DEPRESSION AND WORLD WAR II

The opening of Randolph Air Force Base in 1930 and Lackland Air Force Base in 1941 increased church membership with the addition of more military personnel. In the Great Depression in the 1930s, churches concerned themselves more than ever with the needy. Hard pressed to meet their own financial demands, many churches had to resort to such measures as fundraisers to keep their doors open. Dr. Patrick Miller of First Presbyterian Church (1941–1949) instituted a system of tithes and pledges. In 1942, at the request of community leaders who wanted to maintain a Protestant-related college in the city, Presbyterian-affiliated Trinity University moved from Waxahachie, Texas, to take over the campus of the financially stressed and Methodist-affiliated University of San Antonio.

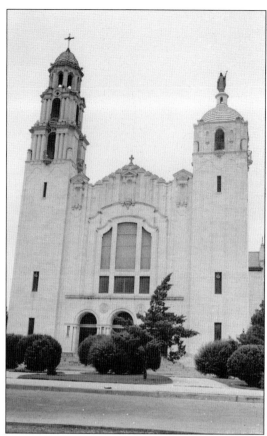

THE GREAT DEPRESSION. The Basilica of the National Shrine of the Little Flower was founded in 1931 by Discalced Carmelite Spanish friars in west San Antonio. The story of the sweet French Carmelite nun Sainte Thérèse de Lisieux, who died of tuberculosis at age 24 in 1897, had a resonance for people suffering from the Depression. Her rose motif appears throughout what is considered by many to be the city's most beautiful church. (Courtesy of University of Texas at San Antonio Libraries Special Collections, L-2972-D, San Antonio Light Collection.)

CHURCH POVERTY. This photograph shows the 75th anniversary celebration in 1971 of the founding of Our Lady of Guadalupe Church. A poor parish during the Depression, it had had to make do with apple crates for chairs in the parish house. The establishment of a national minimum wage in 1933 had only worsened the situation by causing the many local pecan shellers to be replaced by machines. (Courtesy of University of Texas at San Antonio Libraries Special Collections, 072-3616, General Photograph Collection.)

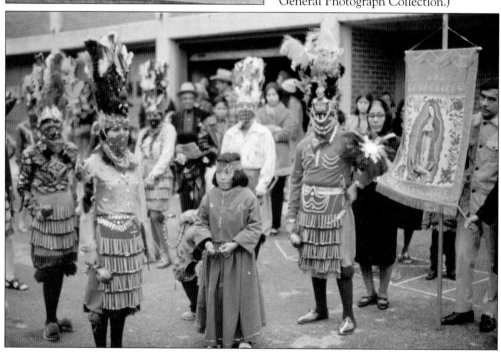

OUTREACH TO THE NEEDY. Jesuit father Carmelo Tranchese (on the right), a University of Naples scholar, was appointed pastor at Our Lady of Guadalupe in 1932. Despite many threats on his life, Tranchese worked with Mayor C.K. Quin to collect food for the hungry and with Congressman Maury Maverick to build the country's first public housing project in 1939. He also started a children's health clinic and founded *La Voz de la Parroquia* newspaper. (Courtesy of Our Lady of Guadalupe Catholic Church.)

ANOTHER EXAMPLE OF OUTREACH TO THE NEEDY. St. Mark's Episcopal Church Community House opened east of downtown in 1939 to give the poor free medical and dental care. In the late 1940s, the Episcopal Diocese of West Texas founded the Good Samaritan Community Services in the poor neighborhood west of downtown. (Courtesy of St. Mark's Episcopal Church, San Antonio, Texas.)

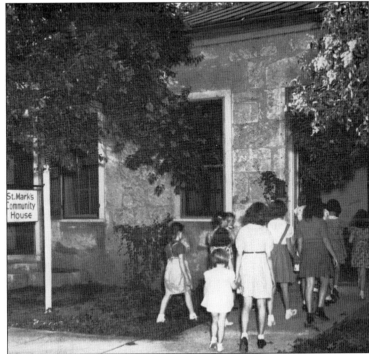

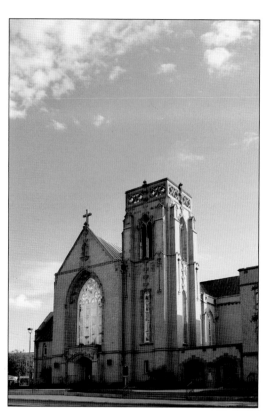

PERSEVERANCE DESPITE HARDSHIP. The Great Depression hit while St. John's Lutheran Church was being remodeled to make way for the widening of Nueva Street. Nevertheless, the present St. John's Evangelical Lutheran Church, shown here, was dedicated in 1932. (Courtesy of St. John's Lutheran Church, San Antonio, Texas.)

SPIRITUAL UPLIFT. In 1935, Frances Craig, a member of Travis Park Methodist Church, with the support of her Philathea Sunday school class, launched *The Upper Room*, a quarterly devotional booklet that gave spiritual uplift in a difficult time. Dr. Grover Emmons supported the first issue with a daring printing of 100,000 copies. The booklet proved immensely popular, selling out, and the series is still being published. (Courtesy of Travis Park Methodist Church, San Antonio, Texas.)

A Do-It-Ourselves Spirit. In 1941, men of Travis Park Methodist Church, in a time of shortage of funds, formed this bucket brigade to dig out a basement for the church that would house Sunday school classes. (Courtesy of Travis Park Methodist Church, San Antonio, Texas.)

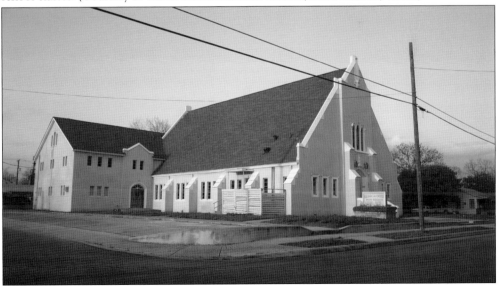

More Self-Help. Thanks in part to the financial support of Elder J.C. Hicks and to the willingness of church members to help work on its construction, the new Harlandale Church of Christ was ready for services in south San Antonio by the end of 1933. (Courtesy of Jeff Tacker.)

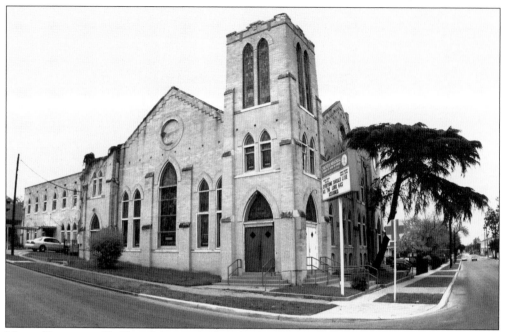

USE OF REVIVALS. Childress Memorial Church of God in Christ, a Pentecostal church, grew out of what was at first called Galloway Tabernacle, planted in 1931. That first congregation emerged out of a 30-day tent revival by J.H. Galloway. (Courtesy of the Childress Memorial Church of God in Christ.)

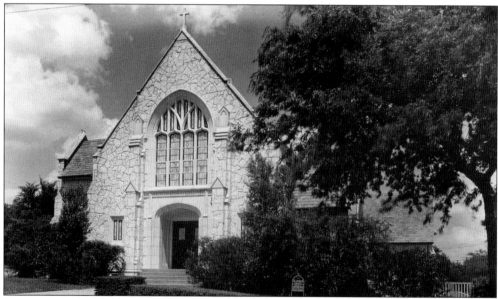

UPLIFT OF CHURCH AESTHETICS. Our Lady of Grace Catholic Church was dedicated in 1938 in the Laurel Heights area and was known as St. Mary's Chapel for its first 14 years. Despite the constraints of the Depression, it has been called one of the most beautiful churches in the United States with its Gothic design and local limestone construction. In 1956, it became the residence and parish of the new auxiliary bishop, Stephen Leven. (Courtesy of the Southwestern Oblate Historical Archives, San Antonio, Texas.)

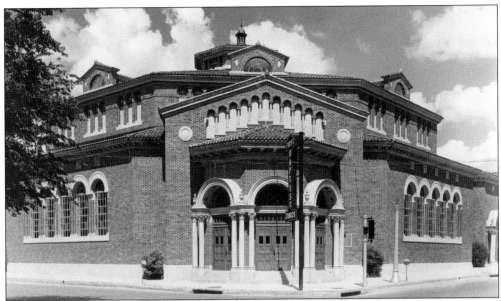

Church Controversy. First Baptist's third church was located at Fourth and Taylor Streets. Dr. C. Roy Angell, its pastor from 1933 to1936, urged men not to waste restricted incomes on sinful activities. He managed to prevent a store across the street, patronized by church members, from selling beer. He also opposed pari-mutuel betting at the Alamo Downs racetrack on Culebra Road. He publicized his views in three books: *Iron Shoes, Baskets of Silver,* and *Price Tags of Life.* (Courtesy of First Baptist Church, San Antonio, Texas.)

Compassion in World War II. This photograph shows the Tea House at the Japanese Sunken Garden in Brackenridge Park. In the anti-Japanese fever after the bombing of Pearl Harbor, the city evicted the Jingu family, which had run the tea room since 1925, cutting off their electricity and water. However, Travis Park Methodist Church provided the destitute family with a temporary home until their relocation to California. (Courtesy of University of Texas at San Antonio Libraries Special Collections, 083-0549, General Photograph Collection.)

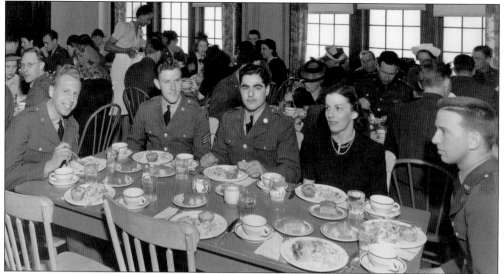

OUTREACH TO SOLDIERS. This photograph shows one of the meals served to servicemen during World War II at St. Mark's Episcopal Church. First Baptist Church sponsored an open house for servicemen on Sunday afternoons, including lunch, and opened the Baptist Soldier Center on Broadway Street. (Courtesy of St. Mark's Episcopal Church, San Antonio, Texas.)

FAMOUS PEOPLE. Here, Lady Bird Johnson is at the dedication in 1983 of a plaque at St. Mark's Episcopal Church in honor of her wedding there to Lyndon Johnson in 1934. Rector Arthur McKinstry was contacted by postmaster Dan Quill only nine hours ahead with a request to conduct the service that evening. Lyndon Johnson, then secretary to Congressman Richard Kleburg, was in a hurry to honeymoon in Mexico and get back to Washington, DC. (Courtesy of St. Mark's Episcopal Church, San Antonio, Texas.)

Eight

THE POST–WORLD WAR II BOOM

The prosperity following the American victory in World War II pushed a new city growth spurt, especially toward the north. Many Irish clergy poured into San Antonio in response to a call from Catholic archbishop Robert Lucey of San Antonio (1941–1969). Between 1952 and 1963, seven new Lutheran churches alone sprang up, an experience common to all denominations. Central air-conditioning in churches became common, replacing handheld fans. As technology surged ahead, Central Christian Church was the first church in San Antonio to air its services on television in 1954.

A national move to social reform culminated in the civil rights movement of the 1960s. Archbishop Lucey organized the Catholic Welfare Bureau, the Catholic Action Office, Project Equality, and the Archdiocesan Councils of Catholic Men, Catholic Women, Catholic Youth, and the Spanish Speaking to fight discrimination in hiring. In 1945, Lucey was made executive chairman of the Bishops' Committee for the Spanish Speaking, later called the Bishops' Committee for Hispanic Affairs. In 1953, Catholic schools were integrated, a year before the Supreme Court ruled against school segregation. Lucey supported the modernization of the Second Vatican Council, attending all four of its sessions and establishing an archdiocesan commission for its implementation.

The Spanish Catholic *cursillo* (little course) movement, emphasizing the presence of Christ and the role of each person in the Christian community, came to San Antonio in 1959. Its song "*De Colores*" celebrated love despite differences, noting the many colors of flowers, birds, and rainbows, and ending "*y por eso los grandes amores de muchos colores me gustan a mí*" (and so great loves across many colors pleases me). In 1972, the Episcopal Church staged a local *cursillo* jointly with the Catholics.

In Protestant developments, the Corral Room under the sanctuary of First Presbyterian Church was created as a haven for servicemen and women during the Korean War. Methodist Hospital opened in northwestern San Antonio in 1963 as the first facility of the South Texas Medical Center.

THE POSTWAR BUILDING SPURT. The first San Juan de los Lagos Catholic Church was opened in 1952 to serve a west-end Mexican American neighborhood that, due to distance, poor drainage, and inadequate streets, had lacked an easily accessible church. The building had been a cantina with the propitious name of *Cielito Lindo*, meaning "beautiful heaven." A new church has been built, but the former saloon still serves as a parish hall. (Courtesy of the Southwestern Oblate Historical Archives, San Antonio, Texas.)

SHRINE OF OUR LADY OF CZESTOCHOWA. This shrine in southeast San Antonio was built in 1966 in honor of Poland's revered black Madonna. Polish nuns run the shrine with Polish masses held daily. The shrine contains a memorial to the Polish silent film star Pola Negri, who retired to San Antonio. (Courtesy of University of Texas at San Antonio Libraries Special Collections, 073-0125a, General Photograph Collection.)

Bishop Jones Center. In 1962, Episcopal bishop Everett Holland Jones moved his headquarters to this scenic hill in Alamo Heights. Today, the center is comprised of Cathedral House, Chapel House, and Cathedral Park. (Courtesy of the Episcopal Diocese of West Texas.)

Pleasant Valley Church in Playland Park, 1963–1971. This chapel was built in 1964 near the roller coaster in Playland Park amusement park at the corner of North Alamo and Broadway Streets (a busy intersection at that time). A recording of the Sermon on the Mount would play here every half hour until the park closed in 1980. (Courtesy of University of Texas at San Antonio Libraries Special Collections, Z-1972-83965, Zintgraf Collection.)

SIDE VIEW OF THE PLAYLAND PARK CHAPEL. This photograph was snapped at an enigmatic moment with headless choristers who seem to be the ones in need of prayer. In 1987, seven years after Playland Park had closed, the chapel was rechristened as St. Edward's Anglican Catholic Church, moved to Anacacho and St. Gertrudis Streets, and given stained-glass windows, a new altar, and a new steeple. (Courtesy of University of Texas at San Antonio Libraries Special Collections, Z-1972-48419, Zintgraf Collection.)

POPULATION MOVE TO THE NORTH. The beginning of Trinity Baptist Church, organized in 1949, illustrates how churches served the new suburbs that were settled by San Antonio's burgeoning population. Before any other structures were built, this open-air podium in the back parking lot of the property was used for outdoor services, as shown here. (Courtesy of Trinity Baptist Church, San Antonio, Texas.)

An Innovative Start. Buses were utilized to accommodate 13 classes for Trinity Baptist men's Sunday school at this time. Two of the women's classes met in the H.R. Saenger's adjacent home, which is now owned by the church. The other women's and the children's classes already had indoor accommodations by 1953. (Courtesy of Trinity Baptist Church, San Antonio, Texas.)

Dr. W.S. McBirnie Speaking at Trinity Baptist's Garden Chapel. Outdoor services were held on Sunday evenings and on such special occasions as Easter Sunrise services. McBirnie, pastor from 1949 to 1959, was an amateur archeologist who went to Holy Land sites nearly every year. He established a small museum at the church with his finds and gave talks on the Holy Land. (Courtesy of Trinity Baptist Church, San Antonio, Texas.)

A Dearly Beloved Sunday School Teacher. Second Baptist Church's Sunday school classes for children posed in this group picture in 1959. Sally Todd taught here for 50 years, from 1939 to 1989. In 2011, she was still regularly attending Sunday school at the age of 98, much loved by several generations of church members and remembered by many as their favorite Sunday school teacher. (Courtesy of Second Baptist Church, San Antonio, Texas.)

The Present Second Baptist Church Building. The present Second Baptist Church, shown here, was completed in 1968 on East Commerce Street and has a basilica-influenced design with a central courtyard containing a fountain, a model that dates back to early Christian Rome. (Courtesy of Second Baptist Church, San Antonio, Texas.)

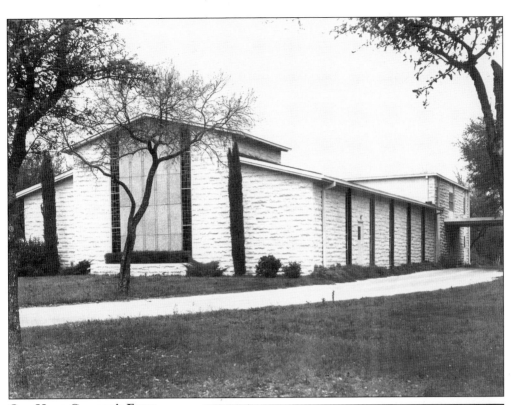

OAK HILLS CHURCH'S FIRST BUILDING. Originally known as Oak Hills Church of Christ, this church was established in 1958. In 1960, it moved into this building on Fredericksburg Road. Max Lucado became pulpit minister in 1988. By the end of 1996, when attendance had grown from the original 52 to over 1,500 members, the elders and congregation decided to move to a 34-acre plot of land just north of Fiesta Texas on Interstate 10. (Courtesy of Oak Hills Church, San Antonio, Texas.)

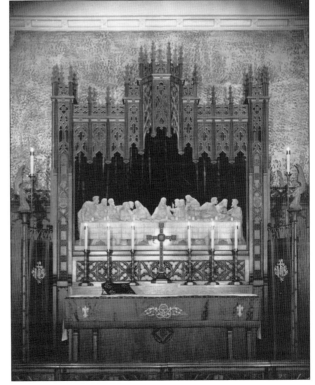

CHURCH AESTHETICS. This altar backdrop depicting the Last Supper in Grace Lutheran Church was dedicated in 1960 and is called by some the "jewel box of San Antonio." (Courtesy of Grace Lutheran Church, San Antonio, Texas.)

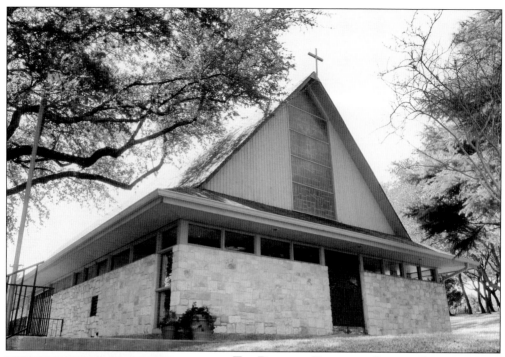

THE BLEND OF FAITH AND BEAUTY. St. Francis Episcopal Church, founded in 1961 and dedicated in 1962, crowns the top of a hill near I-10 and Wurzbach. The structure and woody setting illustrate the Episcopalian marriage of beauty and worship. (Courtesy of the Episcopal Diocese of West Texas.)

THE LORING WINDOW. The 50-foot-high picture window in Travis Park Methodist Youth Building from 1950 illustrates, at the bottom, the Bible's story of creation and the fall from grace (showing Adam eating the fruit from the Tree of Knowledge of Good and Evil). The beholder's eye rises through other Old Testament scenes to the hope of salvation (symbolized by the figure of Christ with outstretched arms at the top). (Courtesy of Travis Park Methodist Church, San Antonio, Texas.)

Church-Sponsored Cultural Events. Female parishioners stand around the *Epitafios* (bier), which symbolized the tomb of Christ on Good Friday in St. Sophia Greek Orthodox Church. In 1961, the annual Greek FUNstival, a three-day event held in the church, was launched and featured Greek food, folk dancing, merchandise, culture, and traditions, plus a guided tour of the church. (Copy courtesy of University of Texas at San Antonio Libraries Special Collections, 073-0443, Mrs. Arthur Sockler.)

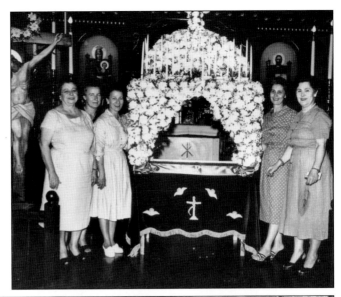

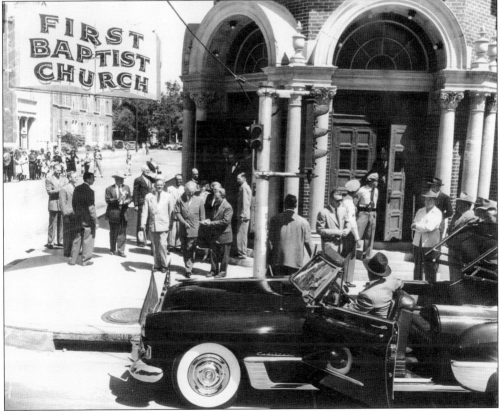

Social Reform. Here, Pres. Harry Truman visits the First Baptist Church in 1948. In his campaign for the presidency in that year, Truman, a staunch lifelong Baptist, toured the country and gave speeches championing the common folk against what he termed the greed of the elite. He warned his listeners that Americans were worshipping Mammon rather than following God's teachings. (Courtesy of First Baptist Church, San Antonio, Texas.)

MORE SOCIAL REFORM. This photograph shows a Sunday school group portrait in front of Mount Zion Baptist Church. In 1949, Pastor Claude Black Jr. led this church to prominence in the National Baptist Convention. A city councilman, Black invited controversial figures (including Thurgood Marshall and Adam Clayton Powell Jr.) to speak from his pulpit, and he led civil rights marches and founded a black credit union. (Copy courtesy of University of Texas at San Antonio Libraries Special Collections, 073-1104, Mount Zion First Baptist Church.)

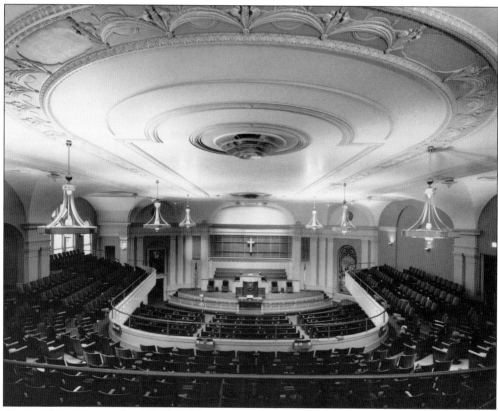

CHURCH INTEGRATION. In 1963, a black lady requested church membership at Travis Park Methodist, whose newly remodeled church is shown here. After a debate on whether or not to accept her application, a statement by Methodist bishop Paul Galloway that said she could not be refused settled the issue. (Courtesy of Travis Park Methodist Church, San Antonio, Texas.)

FIRE DISASTER. Pictured here is the burned-out Travis Park Methodist Church. On October 25, 1955, at about 6:30 a.m., Travis Park Methodist Church's sanctuary was ruined by a fire that started in a basement pantry and worked its way up. The rebuilding was completed in September 1958. (Courtesy of Travis Park Methodist Church, San Antonio, Texas.)

HURRICANE RELIEF. Trinity Baptist has been one of the churches designated as hurricane shelters. Here, refugees from Hurricane Beulah in 1967 are being fed and given cots on which to sleep. At Trinity's invitation, Catholic bishop Stephen Leven arranged for mass to be conducted for the many Catholic refugees. (Courtesy of Trinity Baptist Church, San Antonio, Texas.)

BILLY GRAHAM CRUSADE. Billy Graham praying at a gathering of First Baptist Church. Graham's local crusade in 1946 went forward despite a city-wide quarantine restricting children to their homes during a polio epidemic. (Courtesy of First Baptist Church, San Antonio, Texas.)

BILLY GRAHAM'S RETURN. Pictured here is Billy Graham at the HemisFair Crusade. In 1968, in conjunction with San Antonio's HemisFair World Exposition, Billy Graham returned to San Antonio to hold a HemisFair Crusade in Alamo Stadium. Mayor Walter McAllister proclaimed a preparatory time of prayer, and over 4,000 gave their lives to Christ. (Courtesy of Trinity Baptist Church, San Antonio, Texas.)

Nine

THE LATE 20TH CENTURY

The movement for Mexican American rights continued into this period. Francis Furey, Catholic archbishop of San Antonio from 1969 to 1979, took as his motto *Laborabo non mihi sed omnibus* (I will work, not for myself, but for others). The Commission for Mexican American Affairs was set up in 1970, and the Mexican American Cultural Center was opened at Assumption Seminary in 1973. Furey supported striking garment workers in El Paso and a boycott by the Texas Farm Workers Union. In 1971, the Patrician Movement, founded in 1959 by Fr. Dermot Brosnan, associate pastor in St. Patrick's Parish, opened the La Villita de San Patricio Center for Counseling on Drug Abuse. Patrick Flores, Catholic archbishop from 1979 to 2004, started Catholic Television of San Antonio, the first diocesan television station in the country, in 1981.

Programs for the needy started in this period by Protestants included First Presbyterian Church's Christian Assistance Ministry, the Christian Dental Clinic, Mission Road, Morningside Ministries, Loaves and Fishes, and Victoria Courts Childcare Center. The San Antonio Metropolitan Ministry (SAMM) was set up in 1985 by several downtown churches after a homeless man was found frozen to death on the grounds of First Presbyterian Church in 1981. In 1997, the Salvation Army's Hope Center provided meals for the homeless, an emergency shelter, a homeless child center, an adult day care, and senior support. In 1999, Café Corazón was opened by Travis Park Methodist Church to provide Sunday meals in a congenial atmosphere. San Antonio's healthy church growth also created various mega-churches in this period.

CONTINUING CHURCH GROWTH. This photograph shows the birth of a new church. The members of the newly formed Northwest Church of Christ stand on their undeveloped property on Braun Road in 1980. (Courtesy of Northwest Church of Christ Archives.)

TRANSPORTATION TO CHURCH. Members of Northwest Church of Christ are shown practicing bus repair. Churches of Christ, like many churches, ran buses to pick up families and children to bring them to church services. Many times, these buses needed more mechanical repairs than could be handled by the church. (Courtesy of Northwest Church of Christ Archives.)

JOHN HAGEE'S RISE. In 1987, Cornerstone Church (shown here) opened and was the fourth church founded by pastor Dr. John Hagee. Each previous church (under changing names) outgrew its building, from the first Trinity Church in 1966 through the second Trinity Church in 1972 and Castle Hills Church in 1975. (Courtesy of John Hagee Ministries, San Antonio, Texas.)

HAGEE'S TELEVISION MINISTRY. In 1978, John Hagee began a radio and television ministry. When seven cable companies bid on the right to serve San Antonio, Hagee helped convince the mayor and city council to choose a particular one in return for a contract to have a channel for himself for seven days a week and 52 weeks a year. As a result, Hagee came to be broadcast throughout the world, and he formed a nonprofit corporation, Global Evangelism. (Courtesy of John Hagee Ministries, San Antonio, Texas.)

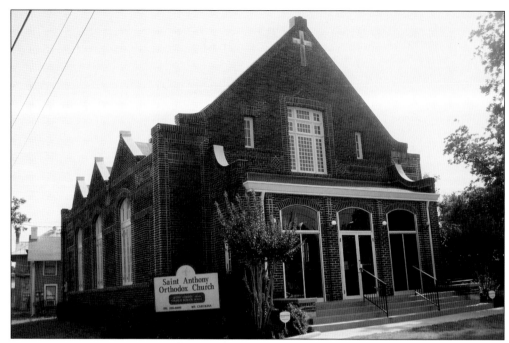

St. Anthony the Great Orthodox Church. The Orthodox congregation purchased First Congregational Church in 1982. The Orthodox Church in America traces back to Russian missionaries in Alaska in 1794 and became independent of the Russian Church in 1970. Its local membership is mostly of Russian and Ukrainian heritage. (Courtesy of St. Anthony the Great Orthodox Church, San Antonio, Texas.)

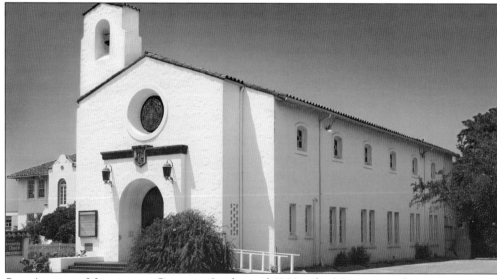

San Antonio Mennonite Church. In the mid-1980s, the Mennonites began meeting in the Fellowship Hall of Westminster Presbyterian Church. They later purchased the church, which they converted into the church shown here. The Mennonites have provided space to the PeaceCenter, Iglesia Menonita Comunidad de Vida, P.E.A.C.E. Initiative, S.N.A.P., Food Not Bombs, a daycare, and a community garden. (Photograph by Walter Iglesias; courtesy of San Antonio Mennonite Church.)

LAYING ON OF HANDS. In the yearlong Mennonite Voluntary Service, young adults come to the city and live together, serving in various nonprofit and citywide agencies while becoming involved in the life of the church. When these volunteers leave San Antonio, members of the San Antonio Mennonite Church encircle them, laying their hands on them with prayers of blessing. (Photograph by Wendell Epp Miller; courtesy of San Antonio Mennonite Church.)

ATTACK IN CHURCH. Pastor John Hagee, shown here, was preaching at Trinity Church about demon possession when an armed man entered and forced his cousin to move from the audience to the podium and beg for mercy. While Hagee stood in front of the intended victim trying to calm the assailant, the assailant emptied his pistol at both. The cousin, shooting back, shot the intruder, but the aggressor's six bullets miraculously missed both Hagee and the assailant's cousin. (Courtesy of John Hagee Ministries, San Antonio, Texas.)

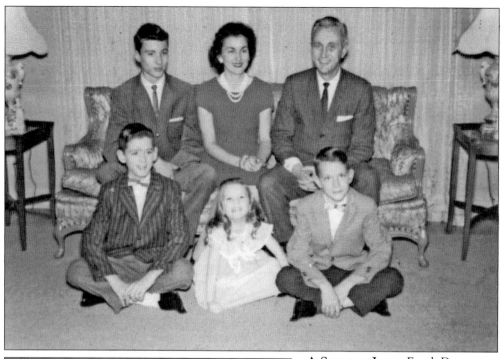

A Spirit of Love. Frank Dunn was the pastor of Jefferson Church of Christ and Family. His daughter Holly (center), singer and songwriter, penned a country-western tribute to her father called "Daddy's Hands" in 1986. She wrote, "I remember Daddy's hands / Folded silently in prayer and reaching out to hold me when I had a nightmare. . . . There are things that I've forgotten / That I loved about the man / But I'll always remember the love in Daddy's hands." (Courtesy of Frank Dunn family.)

Minority Developments. Patrick Flores, the son of migrant workers in the Houston area and a member of the Hispanic Caucus, was named auxiliary to the archbishop of San Antonio in 1970, becoming the first Mexican American bishop in the country. He went on to be a Catholic archbishop from 1979 to 2004. (Copy courtesy University of Texas at San Antonio Libraries Special Collections, 080-0239. Archdiocese of San Antonio.)

OUTREACH TO THE NEEDY. St. Timothy's Catholic Church, dedicated in 1971 to replace an earlier church, sponsored welfare activities, including a job skill center (Operation SER), a senior citizens center, and a child nutrition center, as well as providing classes in basic English and a children's recreation program. (Courtesy of the Southwestern Oblate Historical Archives, San Antonio, Texas.)

MEALS ON WHEELS. In 1977, Christian Senior Services, incorporated jointly by Grace Lutheran Church and St. John's Lutheran Church, started the Meals on Wheels program to deliver meals to the elderly. In 1994, the program moved to a defunct north-side cafeteria. (Courtesy of St. John's Lutheran Church, San Antonio, Texas.)

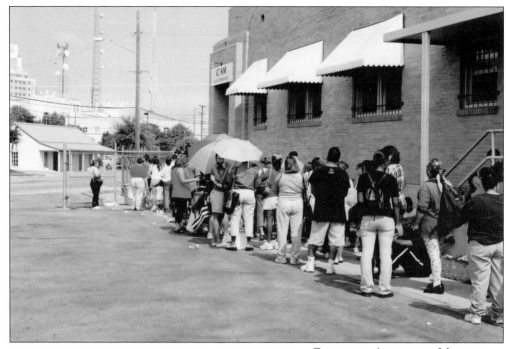

CHRISTIAN ASSISTANCE MINISTRY. Clients are shown lined up at CAM, which started in 1977 through a cooperative effort of several downtown churches to serve the needy. It is housed in a building adjacent to and owned by Grace Lutheran Church. Since 1981, a nighttime shelter has been provided during winter months. (Courtesy of Grace Lutheran Church, San Antonio, Texas.)

HABITAT FOR HUMANITY. Bill Lytle, pastor of Madison Square Presbyterian Church, and his wife founded San Antonio's affiliate of Habitat for Humanity in 1976, providing housing for the homeless. A pacifist supporter of the Fellowship of Reconciliation, he believed that one must sometimes choose God's laws over civil laws at the risk of incurring punishment. (Courtesy of Madison Square Presbyterian Church, San Antonio, Texas.)

SECOND BAPTIST CHURCH CHARITY. In 2003, Second Baptist Church used its Men and Women's Day offering to build its first Habitat for Humanity house in San Antonio. The church had a hospital constructed in Port-au-Prince, Haiti, after that city was hit by Hurricane Ivan. The church also supported the building of a water tower in Haiti to make faucet water available for scrubbing before surgeries. (Courtesy of Second Baptist Church, San Antonio, Texas.)

PASTOR JEMERSON'S CHARITABLE LEADERSHIP. Under Dr. Robert Jemerson Sr., shown here with his wife, Jacqueline, the Second Baptist Church in 2005 launched Vision 2008, committing the African American community to support its underserved. Among other programs, the church's Thanksgiving in the Park Ministry provides food and clothing for the needy. (Courtesy of Second Baptist Church, San Antonio, Texas.)

BISHOP IGELHART'S SOCIAL ACTIVISM. Bishop Samuel Iglehart, pastor of Childress Memorial Church of God in Christ Pentecostal since 1997 and the leader of 145 churches as prelate of the Texas Southwest Ecclesiastical Jurisdiction, became vice chairman of the Community Churches for Social Action and a recipient of the Dr. Martin Luther King Jr. Distinguished Award. (Courtesy of the Childress Memorial Church of God in Christ.)

MISSION TRIPS. Pictured here is Travis Park Methodist missionary youth on a roof in 1989 in Brownsville. Since 1988, Travis Park Methodist Church has sponsored annual summer mission trips to construct churches and other buildings in such needy places as Appalachia, the Rio Grande Valley, and a Navajo Indian reservation. This provides one example of the many mission trips organized by various local churches. (Courtesy of Travis Park Methodist Church, San Antonio, Texas.)

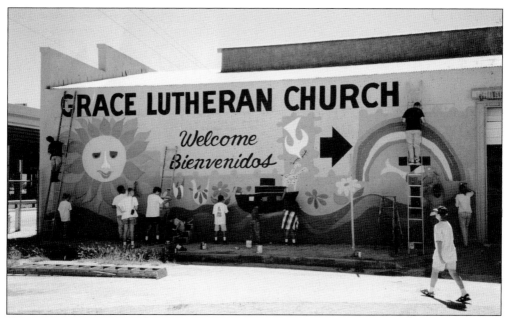

CHURCH AESTHETICS. In the 1990s, Catholic Brother Cletus helped to beautify walls that had been covered by graffiti and covered them with murals. In this photograph, youth of Grace Lutheran Church are painting in colors over outlines that had been drawn by Brother Cletus on the CAM (Christian Assistance Ministry) warehouse. (Courtesy of Grace Lutheran Church, San Antonio, Texas.)

CHURCH-SPONSORED CULTURAL EVENTS. Francis Furey, Catholic archbishop of San Antonio from 1969 to 1979, is shown here blessing the animals at Milam Park in 1973, a tradition followed by the Episcopal Church as well. (Courtesy of University of Texas at San Antonio Libraries Special Collections, 073-1771, General Photograph Collection.)

DECORATING THE EASTER CROSS. On Easter, the San Antonio Mennonite parishioners, young and old, bring flowers forward to decorate the stark wooden cross that has accompanied the services throughout Lent, thereby transforming a symbol of violence and death into a sign of love and hope. This custom is also observed by other denominations. (Photograph by Wendell Epp Miller; courtesy of San Antonio Mennonite Church.)

CASCARONES. At the San Antonio Mennonite Church's annual Easter Egg Hunt, children follow the Mexican tradition of searching for and then breaking confetti-filled eggshells (*cascarones*) over each other's heads. (Photograph by Wendell Epp Miller; courtesy of San Antonio Mennonite Church.)

TRUNK OR TREAT. For several years, Northwest Church of Christ has hosted "Trunk or Treat" each year on Halloween, offering parents a safe and fun place to bring their children. Members decorate the trunks and beds of their vehicles, parked in the parking lot, and the owners greet children who pass by with treats. Thousands of people have visited the event for games, activities, and food. Various churches host the event each year. (Courtesy of Jeff Tacker.)

CELEBRATION OF LEBANESE CULTURE. The third church building of St. George Maronite Catholic, erected in 1980 on Babcock Road, sponsors Lebanese dance and culture, including a monthly Lebanese dinner. Its services include liturgical passages in Aramaic with a touch of Arabic. (Courtesy of University of Texas at San Antonio Libraries Special Collections, 087-0431, General Photograph Collection.)

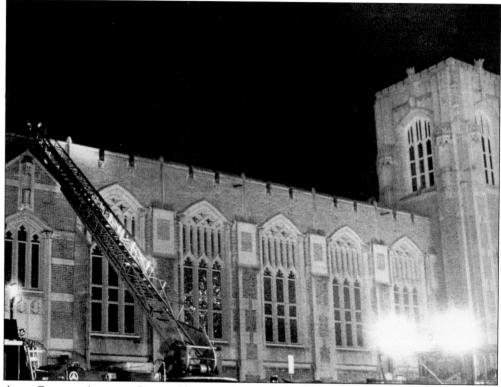

ANTI-CHURCH ATTACKS. Pictured here are fire trucks at Grace Lutheran in 1977. Arsonists set fire to both Grace Lutheran Church and St. Mary's Catholic Church, as well as to several trash dumpsters, between 10 p.m. and 2 a.m. on April 27 and 28. Thanks to a nurse who notified the fire department, the flames were extinguished before the sanctuaries were consumed. (Courtesy of Grace Lutheran Church, San Antonio, Texas.)

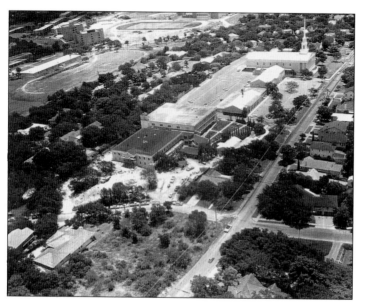

CONTROVERSY OVER FUNDAMENTALISM. In 1990, Trinity Baptist (shown here) rejected the Southern Baptist Convention's fundamentalist stand, which asserted the inerrancy of the King James translation of the Bible. The congregation turned, instead, to the new Cooperative Baptist Fellowship in 1992. In 1994, four women were then elected deacons. (Courtesy of Trinity Baptist Church, San Antonio, Texas.)

Ten

RECENT DEVELOPMENTS

By the early 21st century, new branches of Christianity and other religions—including Congregational, Jehovah Witnesses, Seventh-Day Adventists, Church of the Nazarene, Assembly of God, Salvation Army, nondenominational, Bible Churches, Church of God, Science of Mind, Baha'i, Scientology, and Eckankar—added to San Antonio's religious diversity. San Fernando Cathedral introduced an interfaith Thanksgiving service including pagan Indian ritual dance, a Muslim call to prayer, a Buddhist chant, and Christian hymns.

As San Antonio was hit by the economic downturn, Haven For Hope Homeless Shelter was established downtown. Archbishop Gustavo García Siller, a member of the Mexican Missionaries of the Holy Spirit, continued San Antonio's missionary emphasis. San Fernando Cathedral granted sanctuary to "illegals" seeking refuge from Immigration and Naturalization Service (INS) roundups. INS agents waited to grab suspects as they left the sanctuary, but the church protested when an INS vehicle entered the cathedral space. The controversial foreign wars also left their mark. "Eyes Wide Open," an array of empty army boots left behind by soldiers killed in combat, which the Quakers displayed near the Alamo, provided a current-day statement about the human cost of the wars in the Middle East.

Many of Pastor John Hagee's books, including *The Beginning of the End*, point to Bible prophecies of great tribulations in the end days. Such developments heightened interest in religious consolation. The titles of some of Pastor Max Lucado's books, including *You Are Special*, indicate the Grace-filled theme of his writing. Catholic archbishop Gustavo García Siller, as Simon of Cyrene, carried the cross from Milam Park to Main Plaza on Good Friday in 2011 and spoke to the crowds in English and Spanish of the hope of eternal life through God's only begotten son. Thus, the missionary outreach that gave birth to San Antonio 300 years ago continues to shape the city. The widespread impact of such contemporary religious leaders as Archbishop García Siller and pastors Lucado and Hagee is nothing new. Remember the Alamo.

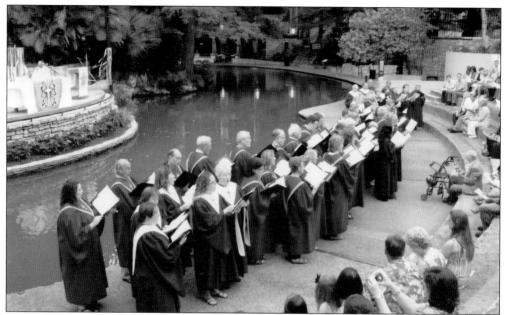

THE FOSTERING OF CULTURE. Pictured here is a service at Arneson River Theater held by Grace Lutheran Church on San Antonio's scenic River Walk. The congregation sits on one side of the river on seats carved out of the hillside rising up to the entry to La Villita, while the service is conducted from the opposite side of the river. (Courtesy of Grace Lutheran Church, San Antonio, Texas.)

DRIVE-THROUGH LIVING NATIVITY TABLEAUX. Here is a manger scene at the huge, drive-through Christmas pageant at Concordia Lutheran Church. Cars drive past a sequence of living tableaux depicting the Nativity story. In 1998, Concordia, which had been founded in 1951, purchased a 48-acre campus on Huebner Road on the north side of Highway 1604 and grew to over 6,000 members. Its new sanctuary, with a 129-foot cross, was completed on this site in 2009. (Courtesy of Concordia Lutheran Church, San Antonio, Texas.)

TABLEAU OF THE WISE MEN. This is a scene of the Magi on their way to visit the Christ Child, one of the many living scenes forming part of the extensive drive-through Christmas pageant at Concordia Lutheran Church. (Courtesy of Concordia Lutheran Church, San Antonio, Texas.)

ICON SCREEN. This hand-carved icon screen in St. Anthony the Great Orthodox Church was created for the church in 2006 by two Bulgarian artists of Sofia, woodcarver Peter Nedkov and iconographer George Goutsev. It features 26 hand-painted icons. (Courtesy of St. Anthony the Great Orthodox Church, San Antonio, Texas.)

CELEBRATION OF ANGLICAN CULTURAL ROOTS. In 2010, St. Francis Episcopal honored the 16th-century impress on its denomination with a Renaissance festival. Singers presented madrigals, popular in the days of the Tudors, and ribbons were wound around a maypole by dancers going opposite directions, a custom dating back to early British fertility celebrations of the divine restoration of life every spring. (Courtesy of the Episcopal Diocese of West Texas.)

ONE OF MANY EXCELLENT CHURCH CHOIRS. University Methodist's traditional choir is a leading example of the many, and it adds to San Antonio's rich musical tradition. Under the direction of Mary McKay, with John Tidmore at the organ, the choir has performed works with the San Antonio Symphony, including a presentation of Karl Orff's *Carmina Burana* in 2009. (Courtesy of University United Methodist Church, San Antonio, Texas.)

PRAYER QUILTS. Each Sunday, University Methodist's traditional service places one or more quilts on the altar railing. Each quilt is accompanied by a photograph of a person or family in need of prayer, and members of the congregation are invited to kneel in prayer before the quilt and tie one knot in its construction. The completed quilt is then given to the person or family prayed for as a token of the concern for them. (Courtesy of University United Methodist Church, San Antonio, Texas.)

POPULATION SHIFTS. Pictured here are the attendees of the last service held at Jefferson Church of Christ, located in the Woodlawn neighborhood, in 2010. Built in 1950, this church is a reminder that congregations sometimes grow old and die. Despite the many years when the church was the largest of its denomination in the city, with up to 600 attendees, the church ended here. (Courtesy of Jeff Tacker.)

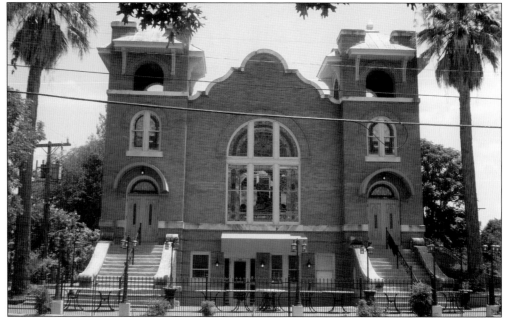

FROM CHURCH TO THEATER. The King William Church Bistro and Theater is another reminder of the transitory nature of some congregations. Built in 1912 on Alamo Street in the King William District as the Alamo Methodist Church, it was converted, a half century later, into the Alamo Street Theater for live presentations of plays and for buffets served in an in-house restaurant, still popular in the 2010s. In 2011, the building was again put up for sale. (Photograph by and courtesy of Kathleen Anzak.)

GENERATIONAL DIFFERENCES. In 2008, University Methodist tried to keep all generations of a family in the same church by opening a North Campus for contemporary music, leaving its South Sanctuary for traditional services. Younger people gravitated north, leaving older worshipers in the South. This walkway between them, over De Zavala Street, symbolizes the attempt to bridge the generational gap. (Courtesy of University United Methodist Church, San Antonio, Texas.)

OUTREACH TO SEXUAL MINORITIES. In 2011, the Episcopal Church of Reconciliation on Starcrest Drive became the first congregation in the Diocese of West Texas to join the "Believe Out Loud" Episcopal group, supportive of bisexuals, gays, lesbians, and trans-genders. A gay and lesbian support group had formed at St. Mark's Episcopal Church in 2003, three months after the election of an openly gay suffragan bishop in New Hampshire. (Courtesy of the Episcopal Diocese of West Texas.)

REACTION AGAINST THE OUTREACH TO SEXUAL MINORITIES. In 2011, the Reverend Chuck Collins of Christ Episcopal Church retired and most of the church's lay leaders resigned in objection to the national church's acceptance of lesbian and gay clergy and other decisions, which they believed strayed from Scripture. Christ Church, located in the Laurel Heights district and designed in the style of an English country manse, is the largest Episcopal church in South Texas. (Courtesy of the Episcopal Diocese of West Texas.)

GROWING RELIGIOUS DIVERSITY. Here is the entry to the Friends (Quaker) Meetinghouse in northeast San Antonio that was built on property purchased in 1998. Believing that there is that of God, the Inner Light, in everyone, the San Antonio Friends Meeting has no pastor, set worship program, hymns, prayers, or sermons. Friends meet in worshipful silence in which any may be moved by the Spirit to speak. Because Friends Meeting believes that no place is more holy than another, the members congregate in a meeting room, not a sanctuary. (Photograph by Daniel Guajardo; courtesy of the Friends Meetinghouse, San Antonio, Texas.)

PATIO OF THE FRIENDS MEETINGHOUSE. Friends Meeting acquired the early name "Quaker," at first a term of ridicule when an English magistrate used it dismissively of George Fox (founder of the Friends Meeting in the mid-17th century), alluding to Friends quaking when moved by the Holy Spirit. This often still happens, and Friends have accepted the nickname. (Photograph by William Osborne Bird; courtesy of the Friends Meetinghouse, San Antonio, Texas.)

A FRIENDS MEETING. The Friends Meetinghouse is square and can hold about 100 people. It is bare with a large window looking out on trees. The Friends sit in a circle, "centering down" in meditative silence, each one becoming still in mind and body. As a deep silence spreads through the room, a "gathered meeting" may occur when the Spirit of God is felt. Friends have no required creed, holding that inward experience of God is necessary for belief. (Photograph by Daniel Guajardo; courtesy of the Friends Meetinghouse, San Antonio, Texas.)

THE LABYRINTH TRADITION. The First Unitarian Universalist Church, off Interstate 410 and close to Interstate 10, contains a rock labyrinth in its front yard. The labyrinth tradition traces back to early Celtic religious initiation rites, which were incorporated into Christianity in the Middle Ages. The Cathedral of Chartres has a labyrinth pattern at its entrance through which pilgrims work their way before entering. Köln Cathedral's labyrinth is at the entryway to its crypt. (Photograph by and courtesy of Kathleen Anzak.)

MESSIANIC JUDAISM. The congregation of Baruch ha-Shem Messianic worship, on Fredericksburg Road, began meeting in 1992. Messianic Jews are Christians who worship in Jesus's Hebrew-language and Jewish religious setting. They are shown worshipping beside a model of the Wailing Wall. This denomination appeals especially to South Texas's *conversos*, whose 14th-century Spanish ancestors were obliged to abandon Judaism publicly but often preserved it secretly. (Courtesy of Baruch ha-Shem Messianic Synagogue, San Antonio.)

SAN ANTONIO TEMPLE OF THE CHURCH OF JESUS CHRIST OF LATTER-DAY SAINTS. The first Mormon congregation in town began in 1921. In 2005, this temple opened on Stone Oak Parkway in northern San Antonio. A Mormon temple is reserved for such ceremonies as baptism and eternal marriage and is open only to Mormons in good standing. A smaller building beside the temple serves as the meetinghouse for Sunday services, where everyone is welcome. (Courtesy of the Temple of the Church of Jesus Christ of Latter-day Saints, San Antonio, Texas.)

STATUE OF THE ANGEL MORONI. This gilded, 13-foot-high statue of Moroni blowing his trumpet stands atop the Latter-Day Saints temple. Moroni is revered as a pre-Hispanic American prophet who, after his death, became an angel and guardian of the golden plates, source for the Book of Mormon. He is believed to have directed Joseph Smith to these plates in western New York in the 1820s. He is said to be the angel of Revelation 14:6, who preaches Christ's gospel to the world. (Courtesy of the Temple of the Church of Jesus Christ of Latter-Day Saints, San Antonio, Texas.)

THE ISLAMIC CENTER OF SAN ANTONIO. This was built in 1996 as the first mosque (*masjid*) in the city and was located on Fairhaven in the north of town. The congregation formed in 1993, meeting first in a convenience store. Members are mainly of Arabic and Indo-Pakistani descent. Two daughter mosques have formed, Al-Medina (City) Mosque on De Zavala Road and Bait al-Maqdes (House of the Holy Place, meaning Jerusalem) on Culebra Road. (Courtesy of the Islamic Center of San Antonio, San Antonio, Texas.)

PRAYER AREA OF THE ISLAMIC CENTER OF SAN ANTONIO. The alcove behind the pulpit (*al-minbar*) serves as the *mihrab* and shows the direction to Mecca, which worshipers face when bowing and praying. The women worship from a separate room in the back, from which they view the *imam* preaching from the pulpit. Friday prayers are packed with over 800 people, but a new facility behind this one is almost complete. (Courtesy of the Islamic Center of San Antonio, San Antonio, Texas.)

THE BAPS SHRI SWAMINARAYAN HINDU MANDIR. This Hindu temple was inaugurated in 2010 on Loop 1604 near I-10. The congregation had been founded in 1999 in an adjacent building, which is still used. This branch of Hinduism has its roots in Gujarat, a state in western India, and services for adults are held in the Gujarati language. The temple teaches moral purity, family harmony, community service, and spiritual progress. (Courtesy of the BAPS Shri Swaminarayan Hindu Mandir, San Antonio, Texas.)

ALTAR IN THE HINDU TEMPLE. The temple inspirer is Pramukh Swami Maharaj, fifth spiritual successor of Bhagwan Swaminarayan, founder of this branch of Hinduism in 1801. The groups of sacred images, from left to right, include Shiva, Parvati, and Ganesh; Krishna (playing a flute) and Radha; Bhagwan Swaminarayan and Gunatitanand Swami; the succession of gurus of the movement in four panels; and Rama and Sita. (Courtesy of the BAPS Shri Swaminarayan Hindu Mandir, San Antonio, Texas.)

THE LIEN CHOW MAHAYANA BUDDHIST TEMPLE. This temple was founded in 2005 by Venerable Thich Chuch Thien. The temple is located in a quiet neighborhood surrounded by trees on the northeast side of San Antonio. Mahayana Buddhism stresses compassion and wisdom and emphasizes the importance of practicing unselfish acts in everyday life. (Courtesy of the Lien Chow Mahayana Buddhist Temple, San Antonio, Texas.)

Interior of the Lien Hoa Buddhist Temple. This temple conducts Sunday services in Vietnamese and promotes evening prayer and meditation session every other day. The temple conducts seminars on Buddhism and holds Dharma study groups. In addition, Chua Phuoc Heu Mahayana Vietnamese Buddhist Temple was founded by Venerable Thich Phuoc Quang on Lockhill Road in northwest San Antonio in 2008. (Courtesy of the Lien Chow Mahayana Buddhist Temple, San Antonio, Texas.)

Aesthetics. The Friends Meetinghouse was designed by Lake Flato Architects. Ted Flato, together with Bob Harris and after consulting with members of the meeting, produced a simple, functional meetinghouse with a meeting room, library, two children's rooms, a kitchen, a walkway, a porch, and storage, considerate of the natural surroundings. (Photograph by William Osborne Bird; courtesy of the Friends Meetinghouse, San Antonio, Texas.)

ILLEGAL IMMIGRATION AND GROWING POVERTY. This benevolence center on Fredericksburg Road was the first location of what is now the Christian Hope Resource Center (CHRC). Oak Hills Church, Jefferson Church of Christ, and other congregations established a new location in 1999 in west San Antonio. CHRC serves emergency food and clothing needs of approximately 5,000 families a month as well as providing life skills education, health services, counseling, and Bible classes. (Courtesy of Oak Hills Church, San Antonio, Texas.)

HAVEN FOR HOPE. This center, sponsored by SAMM, opened in 2010 on a 37-acre campus with 15 buildings west of downtown, including dormitories that house about 1,600 homeless people a night. It provides meals and mental health services, rehabilitates residents, and helps them to find employment and permanent housing. Episcopal, Methodist, Lutheran, Presbyterian, and other churches support the services, which were previously dispersed. (Courtesy of First Baptist Church, San Antonio, Texas.)

THE CONTINUING IMPACT OF SAN ANTONIO'S CHURCHES. Oak Hills Church, in its new location off I-10, thanks in great part to its best-selling author and pastor, Max Lucado, has exerted a mega-impact as a leader among the new mega-churches. Four satellite churches have been launched around San Antonio and in Fredericksburg. The vision is to have a satellite church in all 10 school districts in San Antonio and to bring the presence of Christ to every neighborhood. (Courtesy of Oak Hills Church, San Antonio, Texas.)

PASTORS RANDY FRAZEE (LEFT) AND MAX LUCADO OF OAK HILLS CHURCH. In 2007, Pastor Lucado moved to the position of preaching minister. Together, the two pastors have established 36 area communities in and around the city. The Oak Hills Church mission statement states, "We are the body of Christ, called to be Jesus in every neighborhood in San Antonio and beyond." (Courtesy of Oak Hills Church, San Antonio, Texas.)

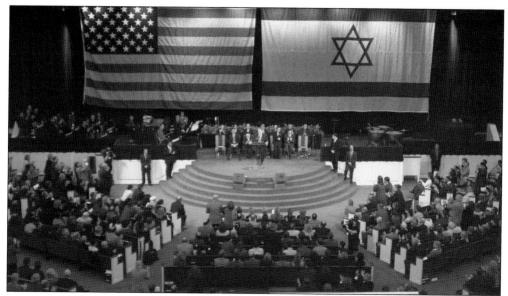

SUPPORT FOR ISRAEL. Pastor Hagee emphasizes Genesis 12:3, where God warns that he will punish nations that come against Israel. He has received thanks from Israeli prime minister Benjamin Netanyahu for his own support of Israel. On November 24, 2002, Hagee started an annual Night to Honor Israel, during which a million-dollar check was presented to the United Jewish Communities for Operation Exodus to bring Jews to Israel. (Courtesy of John Hagee Ministries, San Antonio, Texas.)

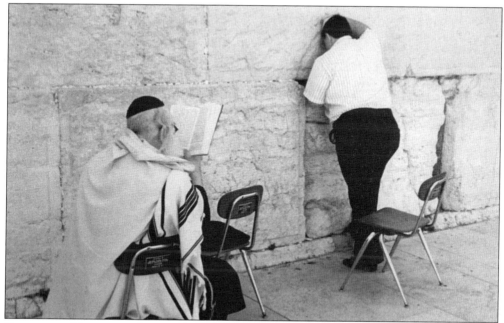

CHRISTIANS UNITED FOR ISRAEL. In 2006, Hagee also founded the Christians United for Israel movement. A CUFI summit was held in the Capitol with more than 3,600 constituents participating, including Senator John McCain. Pastor Hagee has received letters of support from Pres. George W. Bush and Texas senators John Cornyn and Kay Bailey Hutchinson, among others. (Courtesy of John Hagee Ministries, San Antonio, Texas.)

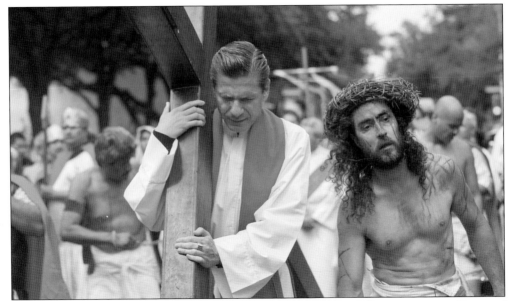

GOOD FRIDAY WITNESSING. Catholic archbishop Gustavo García Siller, representing Simon of Cyrene, carried the cross of Jesus down Dolorosa Street after a dramatization of Jesus's trial on Market Square on Good Friday of 2011. A representation of Jesus's crucifixion followed in front of San Fernando Cathedral. At sunset, Jesus's body was deposited in the cathedral. Starting Easter Sunday, Jesus's resurrection was celebrated through 10 days of fiestas. (Courtesy of Lisa Krantz, *San Antonio Express-News*, ZUMA.)

WARNING OF THE LAST DAYS. This church's name, *La Puerta de Restauración*, calls for spiritual renewal, as does a movie about the last days called *Thief in the Night*, re-shown in May 2011 at the Door Christian Fellowship. With growing class exploitation, corruption, natural disasters, nuclear meltdowns, maritime destruction, threats of war against Israel, and, by one interpretation, 666-based bar codes on credit cards (held in the hand or whose number is given from memory, i.e. the forehead), the call remains urgent. (Photograph by and courtesy of Danny Anzak.)

BIBLIOGRAPHY

Celebrating Fifty Years in Ministry: John Hagee, 1958–2008. San Antonio: John Hagee Ministries, 2008.

Diocesan Historical Commission of the Episcopal Diocese of West Texas. *The Founding of the Churches of the Episcopal Diocese of West Texas.* San Antonio: the Episcopal Diocese of West Texas, 2010.

Elizondo, Virgilio P., and Timothy M. Matovina. *San Fernando Cathedral: Soul of the City.* Maryknoll, NY: Orbis Books, 1998.

Everett, Donald E. *Adobe Walls to Stone Edifice: A Sesquicentennial Pilgrimage of the First Presbyterian Church of San Antonio, Texas, 1846–1995.* San Antonio: First Presbyterian Church, 1995.

First Baptist Church, San Antonio, Texas, 1861–2011. San Antonio: First Baptist Church, 2010.

Fisher, Lewis. *Saint Mark's Episcopal Church: 150 Years of Ministry in Downtown San Antonio, 1858–2008.* San Antonio: Maverick Publishing Company, 2008.

———. *The Spanish Missions of San Antonio.* San Antonio: Maverick Publishing Company, 1998.

Furey, Francis J., Archbishop of San Antonio. *Archdiocese of San Antonio, 1874–1974.* San Antonio: Archdiocese of San Antonio, 1974.

Historical Committee of Trinity Baptist Church, Carl H. Moore, chairman. *God's Lighthouse on a Hill: The First Fifty Years of Trinity Baptist Church, San Antonio, Texas.* San Antonio: Trinity Baptist Church, 1999.

In the Shadow of His Hand: The First Century of the First Baptist Church of San Antonio, Texas, 1861–1961. San Antonio: First Baptist Church, 1961.

Johnson, Craig. *A Century of Grace: A Brief History of Grace English Evangelical Lutheran Church, San Antonio, Texas, 1903–2003.* San Antonio: Grace Lutheran Church, 2003.

Mann, Colleen McCalla. *So We Can Proceed: A History of Central Christian Church in San Antonio, Texas, 1883–1976.* San Antonio: Central Christian Church, 1978.

Sander, Margi, Maxine Sigman, Myrtle Oefinger, Dorothy Hughes, Clyde Gott, and Martha Etter. *The People of God Are the Church Made Visible in the World: The 100 Year History of University United Methodist Church, 1890–1990.* San Antonio: University United Methodist Church, 1990.

To God Alone the Glory: The History of St. John's Evangelical Lutheran Church, San Antonio, Texas, 1857–2007. San Antonio: St. John's Evangelical Church, 2007.

We Finish to Begin: A History of Travis Park United Methodist Church, San Antonio, Texas, 1846–1991. San Antonio: Travis Park United Methodist Church, 1991.

DISCOVER THOUSANDS OF LOCAL HISTORY BOOKS FEATURING MILLIONS OF VINTAGE IMAGES

Arcadia Publishing, the leading local history publisher in the United States, is committed to making history accessible and meaningful through publishing books that celebrate and preserve the heritage of America's people and places.

Find more books like this at
www.arcadiapublishing.com

Search for your hometown history, your old stomping grounds, and even your favorite sports team.

Consistent with our mission to preserve history on a local level, this book was printed in South Carolina on American-made paper and manufactured entirely in the United States. Products carrying the accredited Forest Stewardship Council (FSC) label are printed on 100 percent FSC-certified paper.